狂熱大地
極限攝影精選
Extreme Planet

國家地理攝影師

卡斯坦 · 彼得
Carsten Peter

序 言
Introduction

探索、冒險與發現一直是國家地理學會的核心價值。多年來我們持續擴大對各種遠征的支持，致力於揭露地球各個角落不為人知的面貌。《國家地理》攝影師隨著勇敢無畏的探險隊遠赴世界邊緣，突破種種困境，只為帶回震懾人心的影像。透過他們的作品與故事，我們得以前往地球的不同角落，不僅拓展知識的疆域，也獲得激勵和啟發，關懷我們生活其中的地球。

Exploration, adventure and discovery have been the core values of the National Geographic Society. Over the years we have broadened our support for expeditions, with a commitment to reveal the truth about every corner of the earth. National Geographic photographers have followed fearless expeditions to the ends of the world, overcoming numerous obstacles on a quest to bring back stunning scenes. Their works and stories take us to different corners of the earth, expanding the frontier of our knowledge and inspiring us to care about our planet.

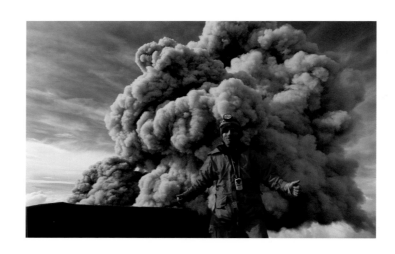

關於本書
About This Book

從岩漿滾燙的火山口、深不可測的洞穴，到致命龍捲風的跟前，本書帶觀賞者跟隨《國家地理》攝影師卡斯坦·彼得的腳步，前往地球上最暴烈的環境，透過撼動人心的旅程，目睹大自然令人屏息的力量。

　　一般人對龍捲風或是岩漿四濺的火山避之唯恐不及，彼得則擁抱自然界最險峻激烈的一面。他持續以冒險犯難的精神挑戰自我極限，不管是最高的山峰還是最深的洞穴，他總是從地球最野性的地方，帶回前所未見的畫面。他說：「最吸引我的是未知。」彼得為大自然混亂而難以捉摸的力量著迷，致力於透過影像，捕捉這個星球最極端而不可思議的時刻。

From bubbling craters, unfathomable caves, to one step away from a deadly tornado, this Book follows the footsteps of National Geographic photographer Carsten Peter to explore some of the most violent environments, taking viewers on an electrifying journey and witnessing the breathtaking forces of nature.

While most people run away from tornadoes or spewing volcanoes, Peter seeks out raucous natural occurrences around the globe. His adventurous spirit drives him to challenge limits, from the highest peak to the deepest shaft, in some of the earth's wildest spots, bringing back never-before-seen images. "I'm most interested in the unknown." Peter surrenders to nature at her most chaotic and unpredictable, capturing the incredible moments of the extreme planet.

攝影師檔案

「 我不是為了追逐危險，只是想呈現大自然的奇景。 」

—— 卡斯坦·彼得

德籍攝影師卡斯坦·彼得專長於極限環境中進行拍攝，展現大自然壯觀的力量。他喜歡在艱難的環境中挑戰自我，並且靠著應變能力與登山、飛行傘、探洞、潛水及峽谷探險等技能在這些環境中生存。他熱衷於研發創新的攝影技術，讓他能在地球上最惡劣的環境中拍下不可思議的景象。由於擅長捕捉大自然的狂野力量，彼得多次獲得《國家地理》雜誌的拍攝任務，包括探索位於越南的全球最大洞穴，以及墨西哥的水晶洞穴。

彼得拍攝美國巨大龍捲風的報導獲得世界新聞攝影獎，在南太平洋垂降至活火山拍攝則讓他獲得艾美獎的攝影獎項肯定。2011年他獲得「國家地理攝影師中的攝影師獎」（National Geographic Photographer's Photographer Award），表揚他拓展攝影的可能性並藉此啟發人心的努力。

彼得總是想創造驚喜，因此作品不侷限於特定的題材或手法，經常以不同的嘗試挑戰自己。自從15歲第一次開始拍照後，彼得再也沒有放下相機，「這個世界很大，我探索過的只是少數地方，還有許多地方等待發現。問題是生命太短暫。」

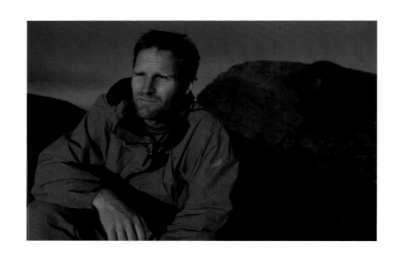

Photographer Profile

I'm not actively looking for danger.
I just want to show the wonders of nature.

—— Carsten Peter

German photographer Carsten Peter specializes in photographing the most extreme environments and showing the spectacular forces of nature. He enjoys challenges in some of the harshest conditions, where he survives on his wits and skills as a technical climber, paraglider, caver, diver, and canyoneer. He is enthusiastically obsessed with devising innovative photographic techniques to capture amazing scenes from the most daunting environments on the planet. His ability to capture images of mother nature's brutal force has enabled him to take on a number of National Geographic assignments, including exploring the world's largest cave in Vietnam and the Cave of the Crystals in Mexico.

Peter's coverage of monster tornadoes in the U.S. earned him a World Press Photo award. He also received an Emmy for his videography from inside an active volcano in the South Pacific. In 2011 he was given the annual National Geographic Photographer's Photographer Award in recognition of his spirit to inspire people by expanding the possibilities of the medium.

In his constant desire to create the element of surprise, Peter is not restricted by specific topics or techniques, often challenging himself with new attempts. He started to photograph at the age of 15, and has not put the camera down since. "The world is so big, these are only little pockets that I have explored, and there are so many more. But my life is too short, that's the problem."

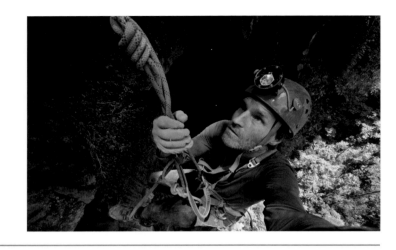

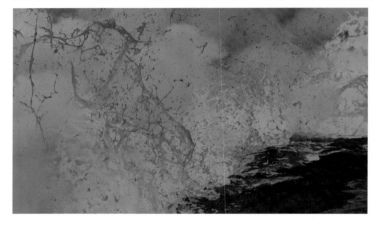

火山爆發 Volcano

剛果民主共和國，尼拉貢戈火山
Nyiragongo Volcano,
Democratic Republic of the Congo

南極洲，伊里布斯峰
Mount Erebus, Antarctica

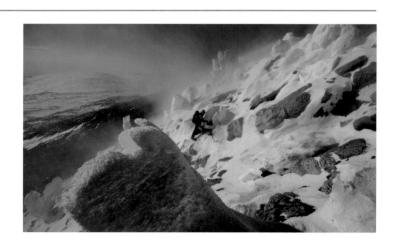

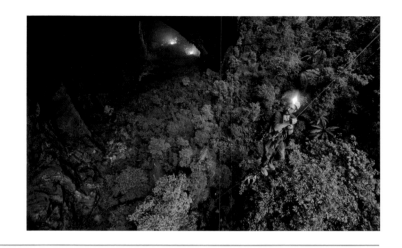

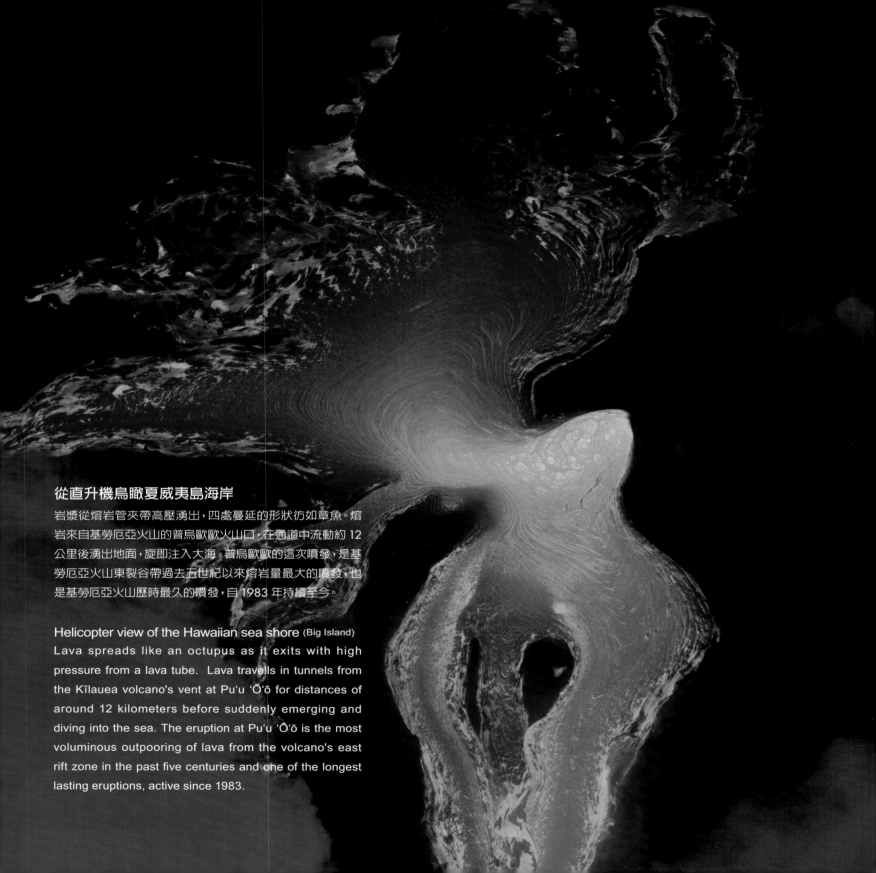

從直升機鳥瞰夏威夷島海岸

岩漿從熔岩管夾帶高壓湧出，四處蔓延的形狀彷如章魚。熔岩來自基勞厄亞火山的普烏歐歐火山口，在通道中流動約 12 公里後湧出地面，旋即注入大海。普烏歐歐的這次噴發，是基勞厄亞火山東裂谷帶過去五世紀以來熔岩量最大的噴發，也是基勞厄亞火山歷時最久的噴發，自 1983 年持續至今。

Helicopter view of the Hawaiian sea shore (Big Island)

Lava spreads like an octupus as it exits with high pressure from a lava tube. Lava travells in tunnels from the Kīlauea volcano's vent at Puʻu ʻŌʻō for distances of around 12 kilometers before suddenly emerging and diving into the sea. The eruption at Puʻu ʻŌʻō is the most voluminous outpooring of lava from the volcano's east rift zone in the past five centuries and one of the longest lasting eruptions, active since 1983.

火山爆發
Volcano

「**彷彿**親眼見到地球誕生之初，那股能量如此巨大，相比下人類渺小無比。」

當一塊塊攝氏1100度的熔岩塊從天而降時，你有想過該怎麼辦嗎？卡斯坦·彼得會告訴你不要動，仔細看，這樣你才會知道它們落在哪裡。彼得在15歲那年造訪了西西里島的埃特納火山，那是他人生第一次造訪火山，他被自然的原始力量深深吸引，從此開啓了30年來拍攝火山的生涯。在火山拍攝的危險除了炙熱的熔岩和突然落下的石塊，還有具強烈腐蝕性的毒氣，不但會傷害人體皮膚和肺部，也會破壞攝影器材。彼得的足跡遍布世界上最危險的火山，他在高溫、酸雨和有毒氣體的惡劣環境紮營，一住就是幾星期、甚至幾個月，以繩索垂降入活火山，近距離記錄大地的原始力量。這些影像集結為《深入火山》一書，中文版於2016年3月推出，使我們得以一窺隱藏在濃煙下的美麗。

"It's like seeing the creation of the Earth. All the energy is so overwhelming; you are tiny compared to that."

What would you do if big chunks of 1100°C lava were falling from the sky? Carsten Peter will tell you to stand still and watch where they fall. His first visit to a volcano was Mount Etna in Sicily when he was 15. Fascinated by the power of nature, Peter began his 30-year career in volcano photography. Shooting at a volcano is accompanied by many risks : Boiling lava, suddenly falling rocks, and corrosive toxic gas that damages skin, lungs, as well as photographic equipment. Peter has traveled to the world's most dangerous volcanoes, camping near the harsh environment of high temperatures, acid rain, and toxic gas for weeks and sometimes even months. Peter rappelled into active volcanoes to capture the primal force from a close distance. These dramatic pictures were compiled into Vulkane, Chinese edition published in March 2016 by Boulder Media, revealing the beauty hidden in the smoke.

果民主共和國，尼拉貢戈火山

agongo Volcano, Democratic Republic of the Congo

尼拉貢戈火山，海拔高度3470公尺，是全世界最活躍也最險惡的火山之一。主火山口深度為250公尺，最寬處有2公里，擁有全球最大的熔岩湖。山腳下人口約100萬的哥馬市，被視為世界上生活最危險的地方之一。尼拉貢戈火山在近年來曾噴發兩次，1977年的噴發造成約2000人死亡；2002年則摧毀1萬多戶民宅，使35萬名居民無家可歸。彼斯坦·彼得參與了前往尼拉貢戈火山的國家地理遠征隊。科學家希望能更了解這座火山，以預測下一次的噴發，而彼得原先的任務是記錄科學家的工作，但是第一天過後，卻只剩下他一個人留在最接近熔岩湖的營地。第二天彼得隻身攀爬到熔岩湖邊緣，與滾燙的岩漿只有咫尺之遙，「我可以感覺到轟隆隆的震動，彷彿自己就站在地球的脈搏上，真令人著迷。」

Rising 3,470 meters above sea level, Nyiragongo Volcano is among the most active and dangerous volcanos in the world. Its main crater is 250 meters deep and 2 kilometers wide, holding the largest lava lake on earth. At its foothill sits Goma City, with a population of approximately one million, and considered one of the world's most dangerous places to live. Nyiragongo Volcano has erupted twice in recent history. Once in 1977, which killed roughly 2000 people; again in 2002, destroying more than 10,000 houses and leaving 350,000 people homeless. Peter took part in the National Geographic expedition team to the Nyiragongo Volcano. Scientists aimed to better understand the Devil's Blast to predict its next eruption. Peter's mission was to document the scientists' work; however, he was the only one left staying at the camp site closest to the lava lake after the first day. The next day, Peter climbed to the rim of the lava lake by himself, only a few steps away from the boiling lava. "You feel the rumble, as if you are directly on the pulse of the earth, it's so mesmerizing."

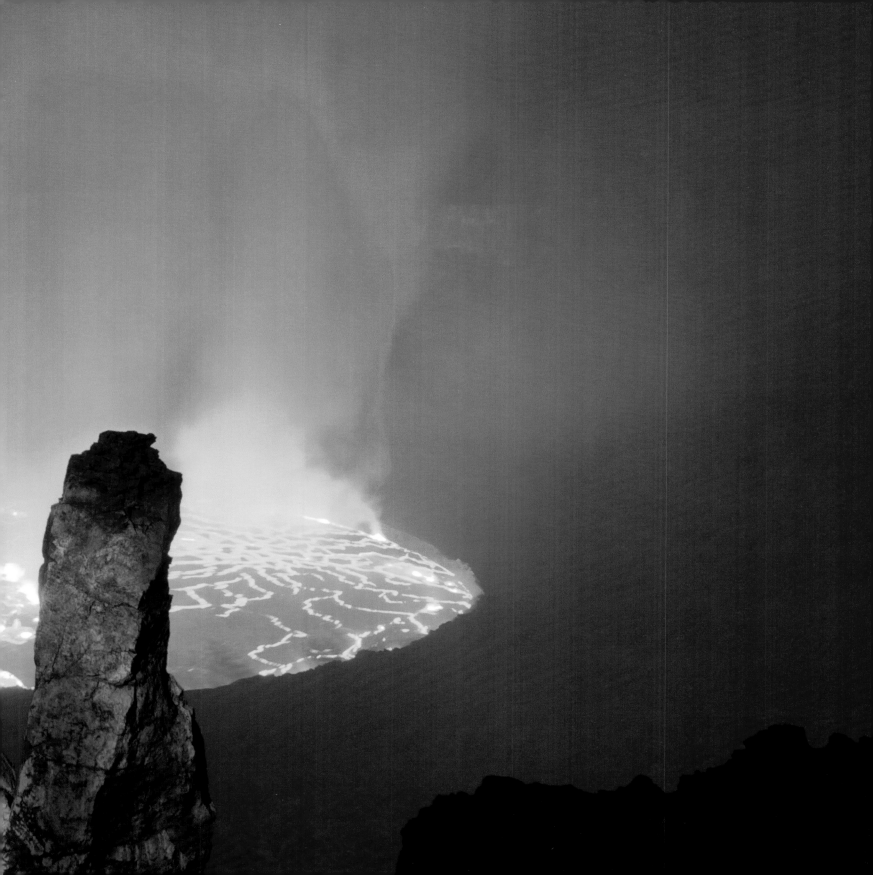

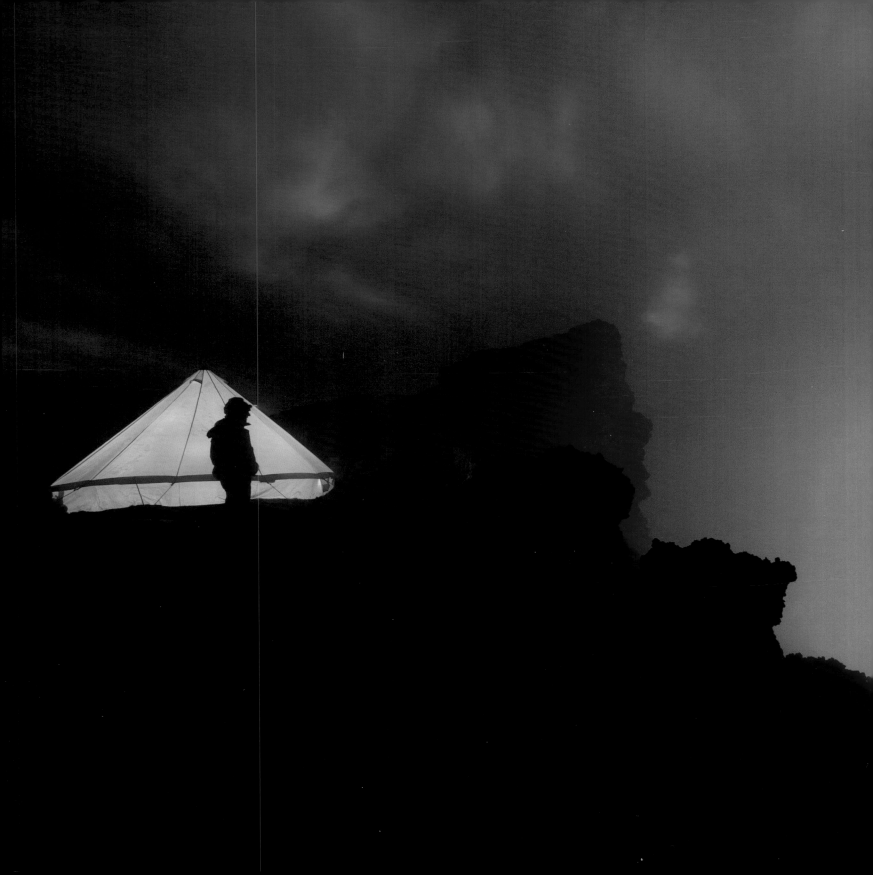

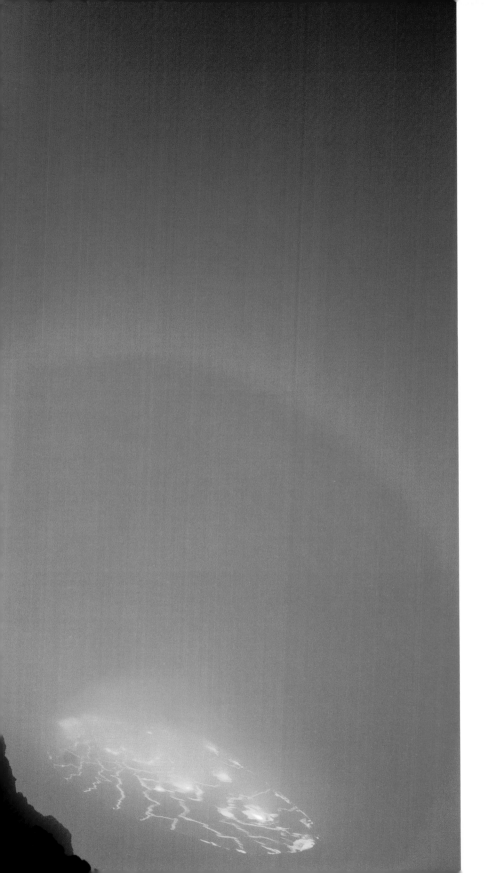

巫婆釜旁的炊事帳
The cooking tent near the witch's cauldron

剛果民主共和國，尼拉貢戈火山
Nyiragongo Volcano, D. R. Congo

火山也許是最無法掌控的自然現象之一，它的狂暴凸顯出人類的渺小，在垂降進入火山時這種感覺尤其強烈。探險隊基地營設置在尼拉貢戈火山的山頂（海拔 3470 公尺），隊員在冰冷低溫中俯瞰全世界最大熔岩湖的炙熱火光。

Volcanos are perhaps the most uncontrollable natural phenomena. Their violence relativizes the scale of the human existence, especially when you enter their abyss and descend into their innermost part. The base camp is located on the peak of the Nyiragongo volcano (3470m). In freezing temperatures, team members gaze at the biggest lava lake on the planet.

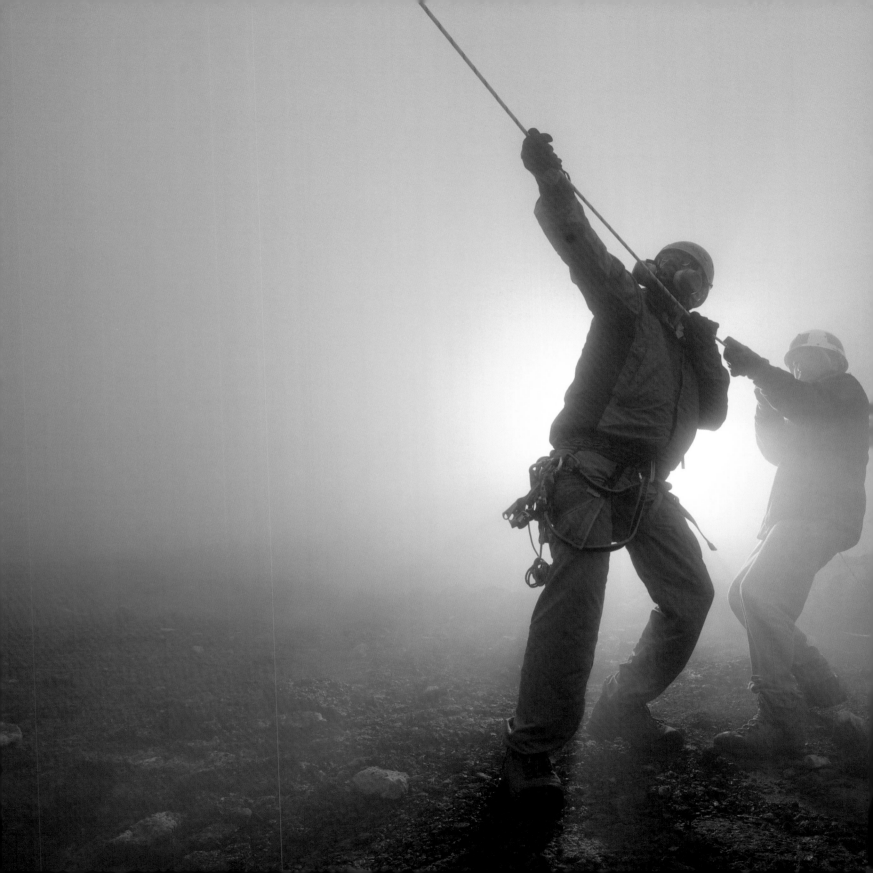

毒霧中的苦役
Hard labor in corrosive fog

剛果民主共和國，尼拉貢戈火山
Nyiragongo Volcano, D. R. Congo

沿著垂直的火山坑壁垂降數百公尺，經過一層層火山灰和不穩定的碎屑，是一場高風險的賭注：此時身處地質構造不穩定的表面，經常發生落石和地震，有時候還必須穿過硫磺、鹽酸和氫氟酸微滴形成的毒霧。重型裝備須用鋼索運送下來。

The descent, several hundred meters along vertical crater walls, passing ashy layers and wobbly rubble, is a high-risk gamble. You are on a tectonically unstable surface, where rock falls and earthquakes are common phenomena. Sometimes you will dive into poisonous fog composed of sulphur, hydrochloric and hydrofluoric acid droplets. Heavy equipment has to be lowered down by a wire rope.

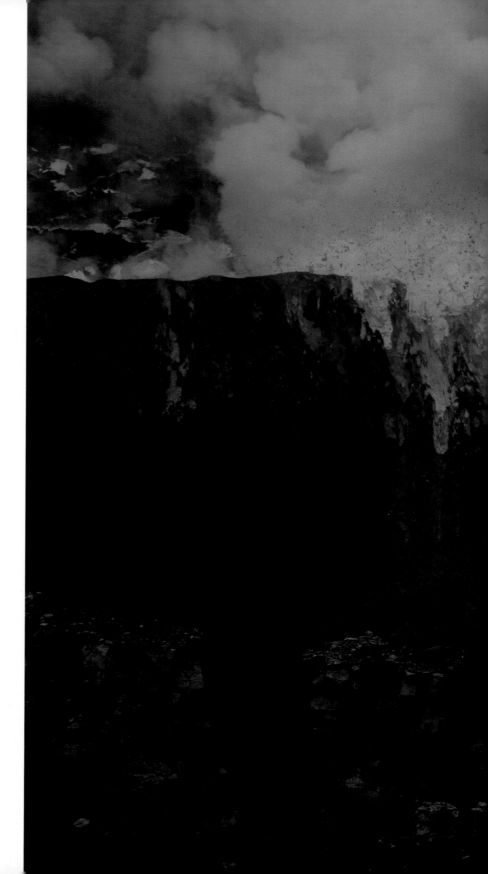

沸騰的熔岩
Lava boils over

剛果民主共和國，尼拉貢戈火山
Nyiragongo Volcano, D. R. Congo

滾燙的岩漿像一片廣闊的水域，僅靠火口環脆弱的熔岩壩圍住。熔岩壩由飛濺出的岩漿逐漸堆高而成，但愈來愈活躍的火山活動一再考驗著壩體的極限，有時熔岩會溢出，淹上第三層平臺。當熔岩壩的頂部被岩漿侵蝕得太多，巨大的熔岩塊就可能掉入山谷。

The wide sea of boiling lava is held together only by a delicate ring dam. It steeply builds itself up with spattering lava, and is repeatedly tested by increasing activity. Then the dam may be washed over and lava floods the third terrace. With that the dam crest can erode so much that huge lava clods fall into the valley.

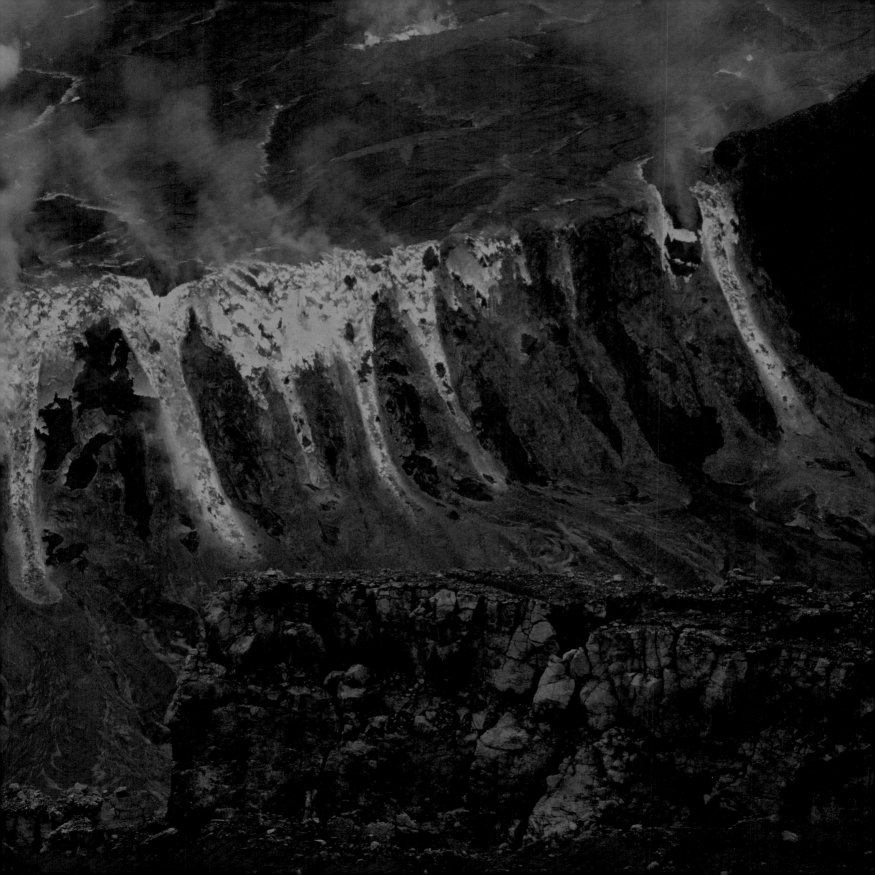

熔岩紅光
Lava redness

剛果民主共和國，尼拉貢戈火山
Nyiragongo Volcano, D. R. Congo

探險隊員克里斯·漢萊恩正在探索第三層平臺上由新鮮熔岩形成的地面，在他身後是高度已經上升的熔岩湖。熔岩壩如果破裂，後果將不堪設想，他很可能無處可逃，而種種跡象顯示這種事情以前曾發生過。沸騰的熔岩湖泛著橘光，把周圍染成一片神祕的岩漿紅。

Chris Heinlein explores the ground made of fresh lava on the third terrace. Behind him the heightened lava lake sits like a throne. A bursting of the dam would be a disaster and there would most likely be no escape. There are signs that this happens from time to time. The glowing orange of the bubbling lake submerges the environment into a mysterious lava red.

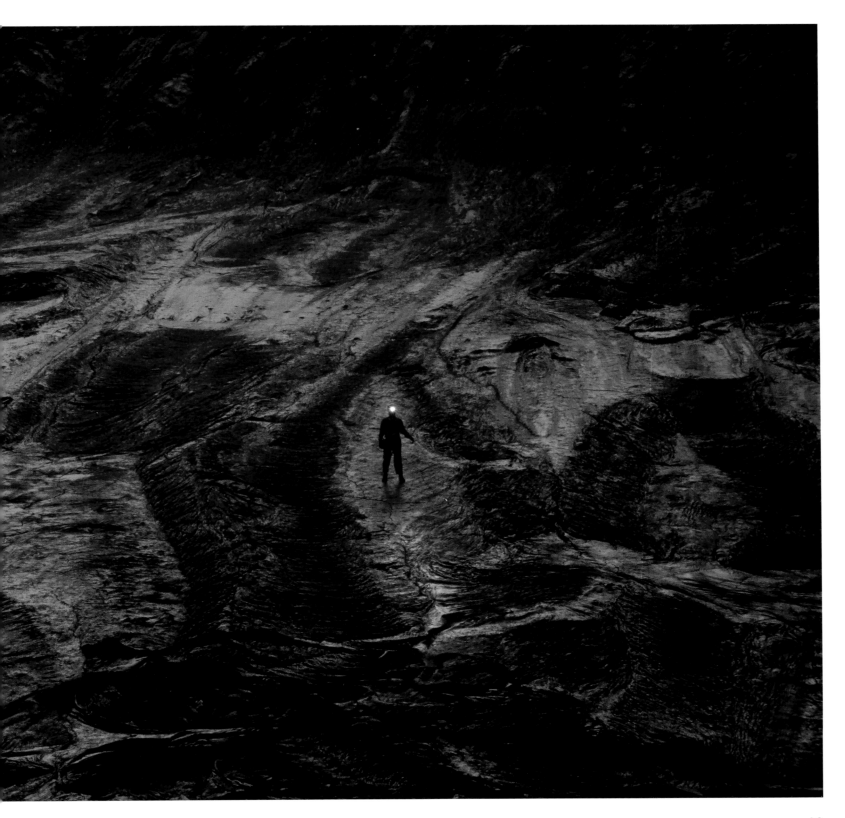

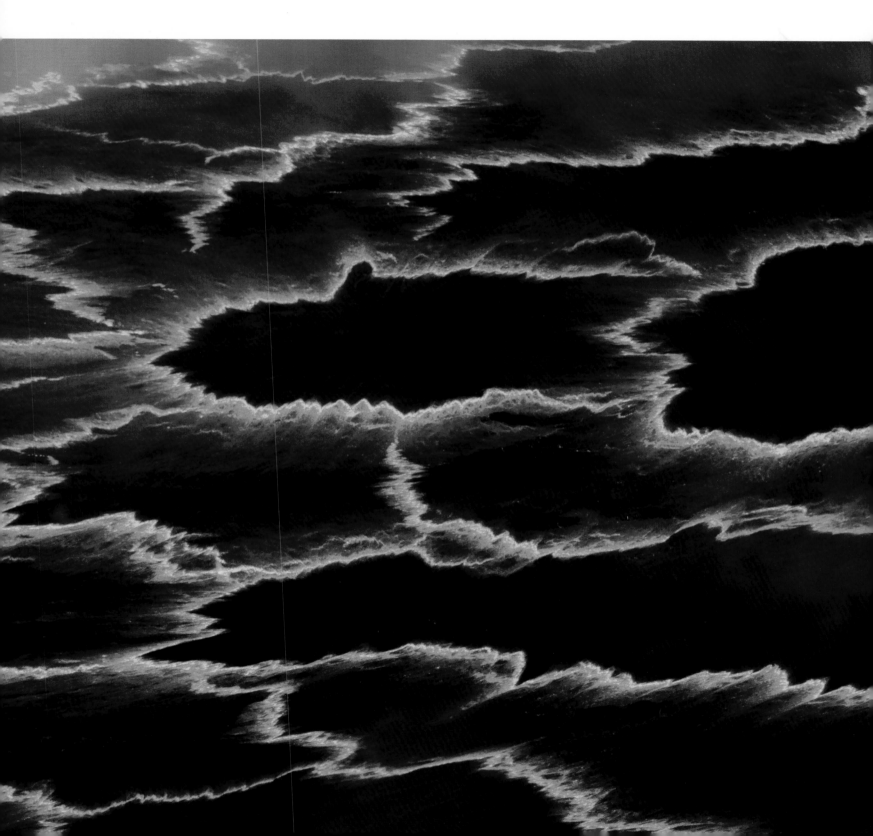

微型大陸漂移
Continental drift in miniature

剛果民主共和國，尼拉貢戈火山
Nyiragongo Volcano, D. R. Congo

在休眠期間，這座全世界最大的熔岩湖表面會產生彷彿大陸漂移的運動，這些緊密的幾何圖案有各種動態：被岩漿拉開、撕裂、吞噬並重生。這樣的循環有如發生在大陸邊緣的地質事件，只是規模小得多，並且彷彿以縮時攝影的方式出現在眼前。

During the rest periods, the surface of the biggest lava lake on earth does a continental drift in miniature. The strict graphical pattern has all kinds of dynamics - places will be pulled apart by the streams in the lake; ripped apart, devoured and reborn. It is a cycle that can be compared to the events happening at our continental margins, but much smaller and as if seen in a time lapse.

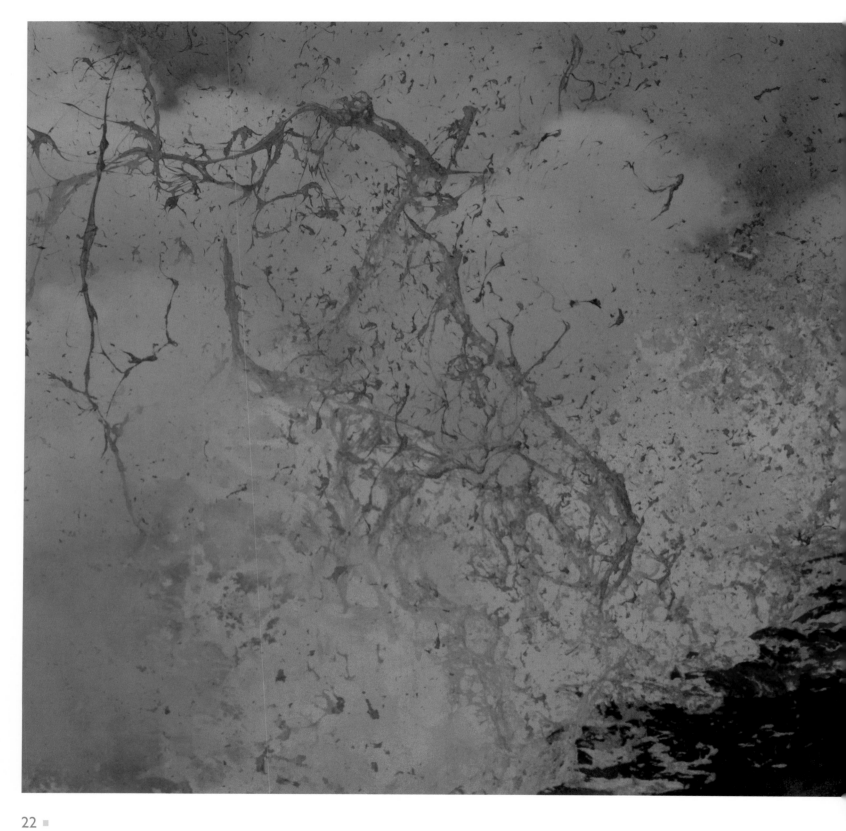

熱力四射
Hot shot

剛果民主共和國，尼拉貢戈火山
Nyiragongo Volcano, D. R. Congo

尼拉貢戈火山是全世界溫度最高的火山，有些地方甚至會達到攝氏 1300 度，因此岩漿非常稀薄，能以每小時 100 公里的速度沿著山坡流入山谷，在極短時間內造成巨大的破壞，2002 年光是在哥馬市就摧毀了 4500 間房屋。這張照片可以看到高溫的氣泡撕裂液態岩石，彷彿爆炸一般。

It's the hottest volcano on the planet, in some places over 1300°C, therefore the lava is extremely thin. It reaches a velocity of up to 100 km/h when it shoots down the mountainsides into the valley, and can cause huge damage in a short time. In 2002, 4500 houses were destroyed in Goma alone. In this picture, gas bubbles tear apart liquid rock as in an explosion.

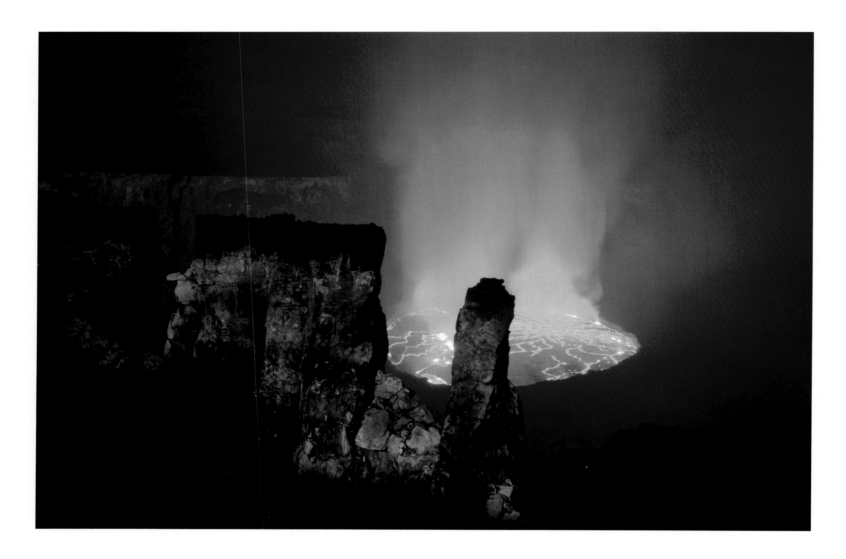

消失的平臺
The death of a terrace

剛果民主共和國，尼拉貢戈火山
Nyiragongo Volcano, D. R. Congo

就像冰川一樣，火山口的第二層平臺有大塊位於第三層平臺底下，形成充滿傾斜岩塔與平衡石的脆弱岩石結構。平臺表面會隨著時間不斷變小，第一層平臺只殘存一點邊緣。只有心臟很強的人才膽敢通過那些搖搖欲墜的岩塔。

Like in a glacier, huge pieces of the second terrace lay beneath the third one. It opens up fragile rock formations with leaning towers and balancing stones. Over time, the terraces lose more and more of their surfaces. From the first terrace, there are only marginal remnants. The passage of those wavering towers is not for the faint-hearted.

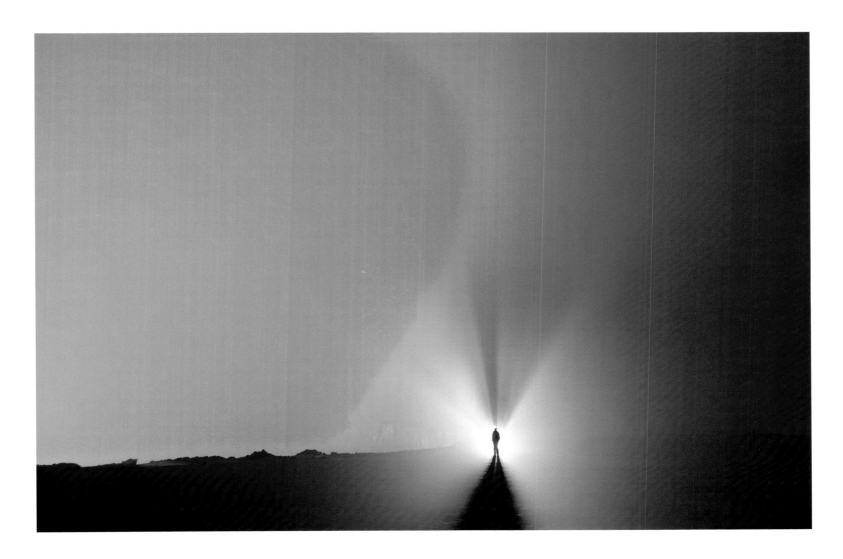

火山煙霧
Volcanic smog

剛果民主共和國，尼拉貢戈火山
Nyiragongo Volcano, D. R. Congo

火山口要是通風不好，就會瀰漫著火山煙霧，這種由硫氧化物、氯化氫、氮氧化物及氟化氫混合而成的高腐蝕性氣體，會侵蝕肺部，也會在皮膚與黏膜留下痕跡，即使防毒面罩能提供的保護也有限。這張照片也許是火山煙霧唯一讓人覺得美麗的地方。

If the crater is not well ventilated, the vog will take over. (Like smog, only with a volcanic origin.) It is an extremely unpleasant cocktail made of corroding gases - sulphur oxide, hydrogen chloride, nitrogen oxide and even hydrogen fluoride, which digs into lungs and leaves traces on skin and mucosa. Even gas masks give only limited protection. The only beautiful thing about the vog is perhaps this picture.

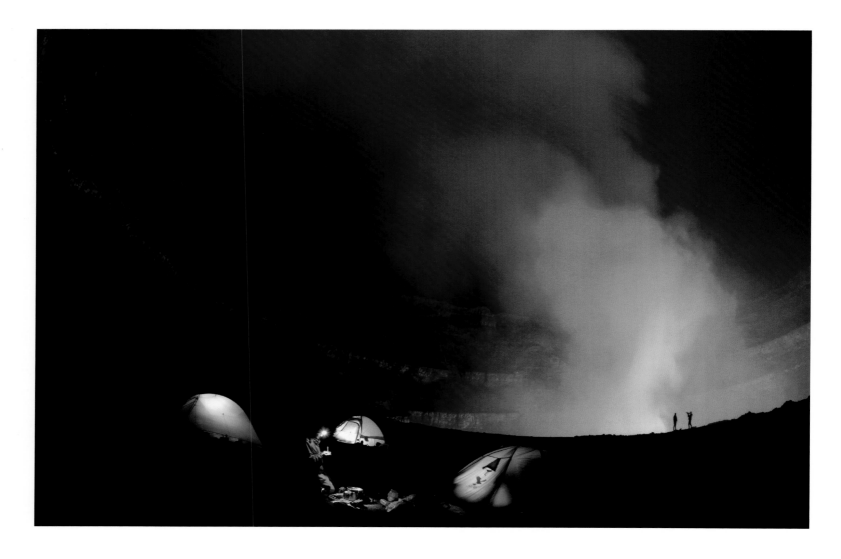

極限露營
Extreme camping

剛果民主共和國，尼拉貢戈火山
Nyiragongo Volcano, D. R. Congo

在尼拉貢戈火山口內的第二個平臺上紮營，有幾個優點：峰頂的氣溫有時會降到零度以下，平臺的地面至少提供了一些暖意，而且從這裡可以俯瞰第三個平臺和地球上最大熔岩湖的壯觀景色。不過，科學家團隊和攝影小組只在平臺上待了一個晚上就速速離開，因為那裡充滿了令人窒息的酸性氣體。

Camping on the second terrace inside the crater of Nyiragongo volcano had several advantages: The ground provided some warmth (outside temperatures on the summit could become below freezing) and there was a spectacular view down to the third terrace and the biggest lava lake on earth. A team of scientists and a camera crew spent only one night there though, because acid gasses were filling the location.

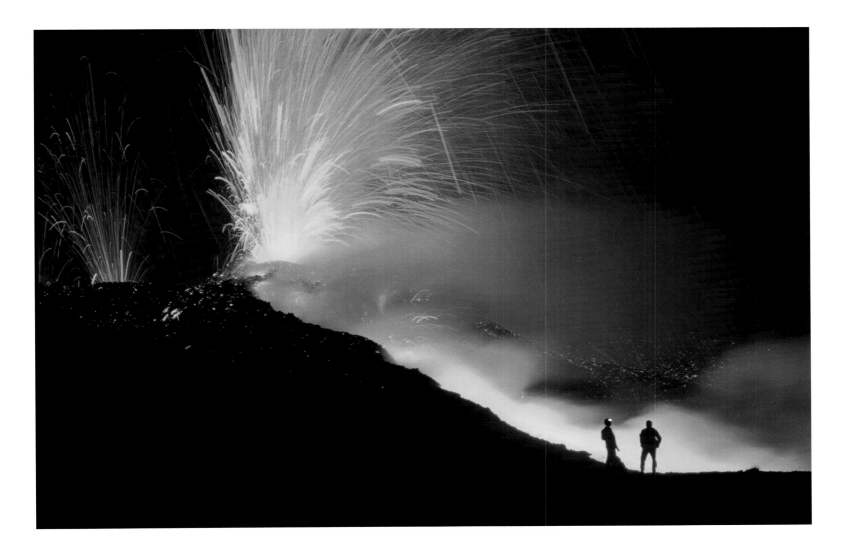

埃特納噴發
Etna erupts

義大利西西里島，埃特納火山
Etna, Sicily, Italy

位於義大利西西里島的埃特納火山是歐洲最大的火山，它在 2001 年的噴發非常特殊，不但在火山兩側出現七個不同的裂口，噴發的岩漿更是經由兩個各自獨立的通道上升到地表。其中一條通道穿過一處小的含水層，因而造成威力強大的爆發式噴發。圖中可見位於海拔約 2100 公尺處的最低一處裂口，兩名追火山的人正朝紅光閃爍的熔岩流前進。

The 2001 eruption on Etna, the biggest volcano in Europe, was a very special event. Seven fractures opened on both sides of the mountain and the eruption was fed through two different and independent conduits. One was cutting through a small aquifer, causing very powerful and explosive eruptions. Here you see the lowest opening at around 2100 meters; two volcano chasers approach a glowing river of lava.

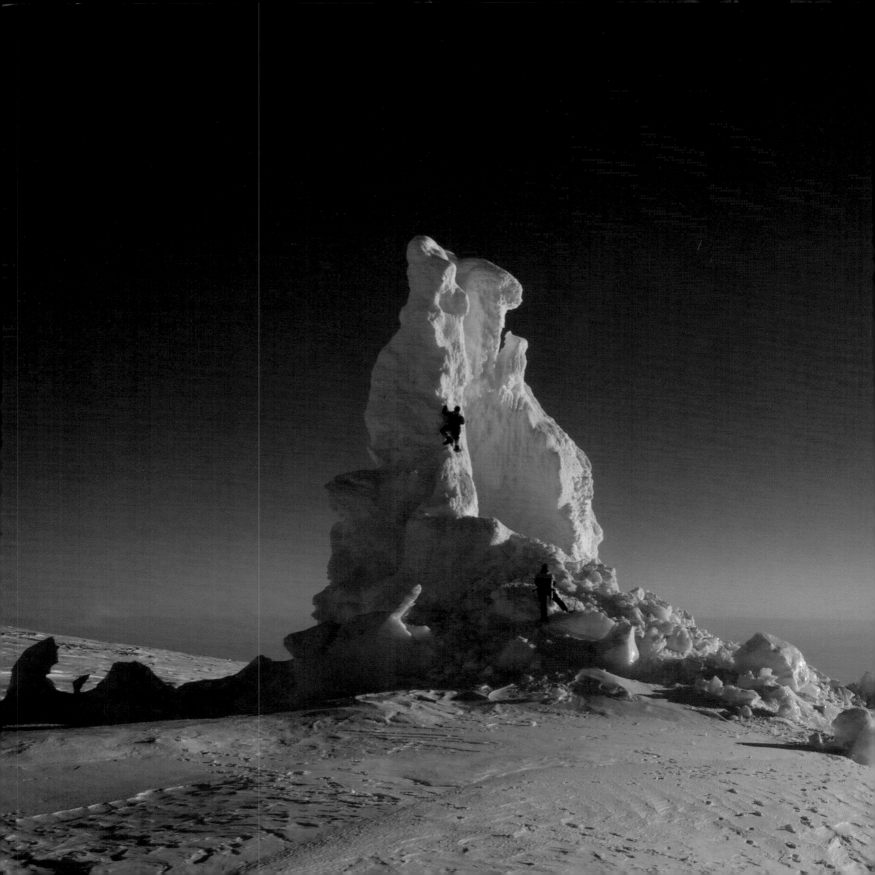

南極洲，伊里布斯峰

Mount Erebus, Antarctica

終年和冰雪相伴、偶爾被熔岩流覆蓋的伊里布斯峰，是地球最南端的活火山。伊里布斯峰海拔高度3795公尺，活火山口寬約800公尺，深275公尺，有一座罕見的熔岩湖。卡斯坦‧彼得隨著一組微生物學家深入這全世界最冷的地方，尋找在酷熱環境中蓬勃發展的生物，拍攝的影像發表在《國家地理》雜誌2012年7月號的報導中。伊里布斯峰以擁有眾多噴氣孔聞名，噴氣孔的高溫和溼潤泥土為苔蘚和微生物提供了理想的生長環境。噴氣孔的型態非常多元，有的像高塔，有些形成洞穴，而位於表面的冰則彷彿凍結的海浪。伊里布斯峰的地貌包含火山、冰川及洞穴，都是彼得擅長在其中活動與拍攝的地形。一般人也許以為在極地拍攝相對比較輕鬆，然而冰川變化多端，潛藏了許多無法預測的危險。

Covered with ice, snow, and the occasional lava flow, Mount Erebus is the southernmost active volcano on the planet. Standing 3,795 meters above sea level, the volcano's active crater is 800 meters wide and 275 meters deep with a rare lava lake. Peter followed a team of microbiologists deep into the coldest spots on Earth in search of beings that thrive in blistering heat, which were featured in National Geographic magazine in July 2012. Mr. Erebus is notable for its numerous ice fumaroles—vents where the volcano releases gases—with high temperatures and moist soil, creating a suitable environment for moss and microbes. The forms of the fumaroles are very diverse. Some are like towers, others form caves, and the ice on the surface looks like frozen sea waves. The terrains of Mount Erebus include the volcano, glaciers and caves, all of which are Peter's specialties. Some may think shooting in the polar is relatively easy, but in fact the fickle nature of glaciers holds many unpredictable dangers.

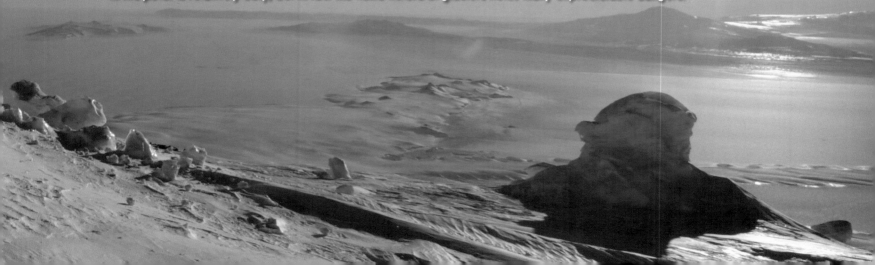

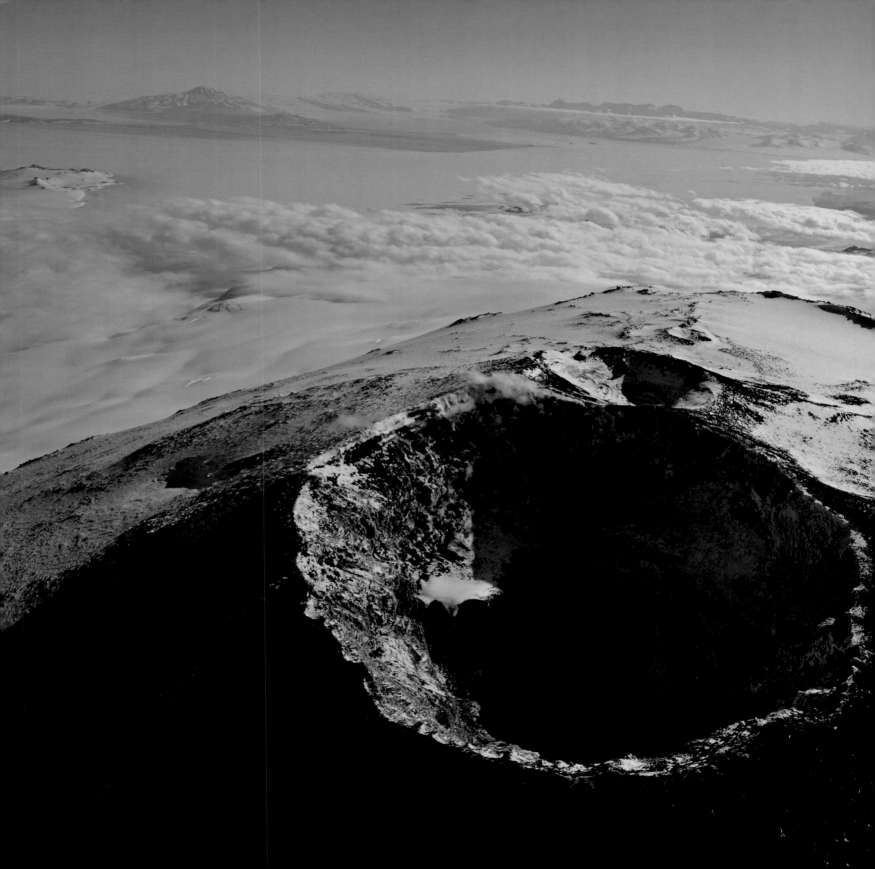

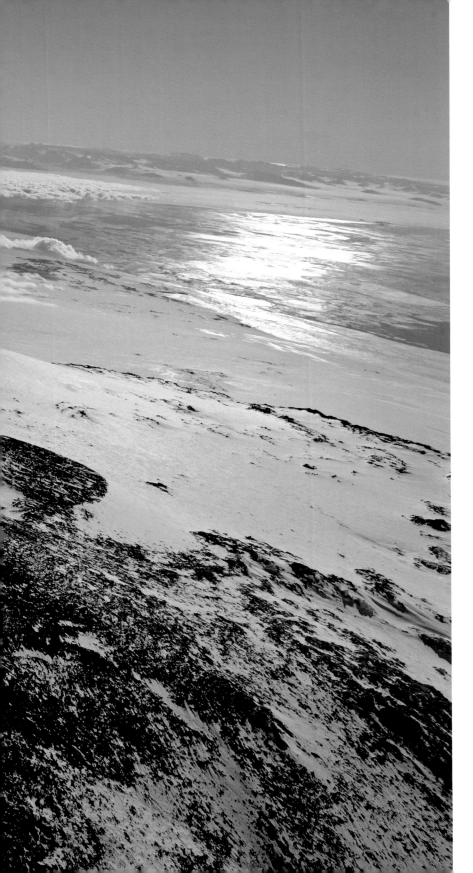

永凍的熱點
Hot spot in the eternal ice

南極洲，伊里布斯峰
Mount Erebus, Antarctica

伊里布斯峰是地球最南端的活火山，位於南極大陸近海的羅斯島上，火山口有一座永久性的熔岩湖。曾經站上伊里布斯峰頂的人比登上聖母峰的人還要少，但這座山卻是最多人造訪的火山之一。

Mount Erebus (3794m) is the southernmost active volcano on earth and lies offshore of the Antarctic ice desert on Ross Island. Fewer people have stood on its peak than on the peak of Mount Everest, yet it is one of the most visited volcanos. In its throat is a permanent lava lake.

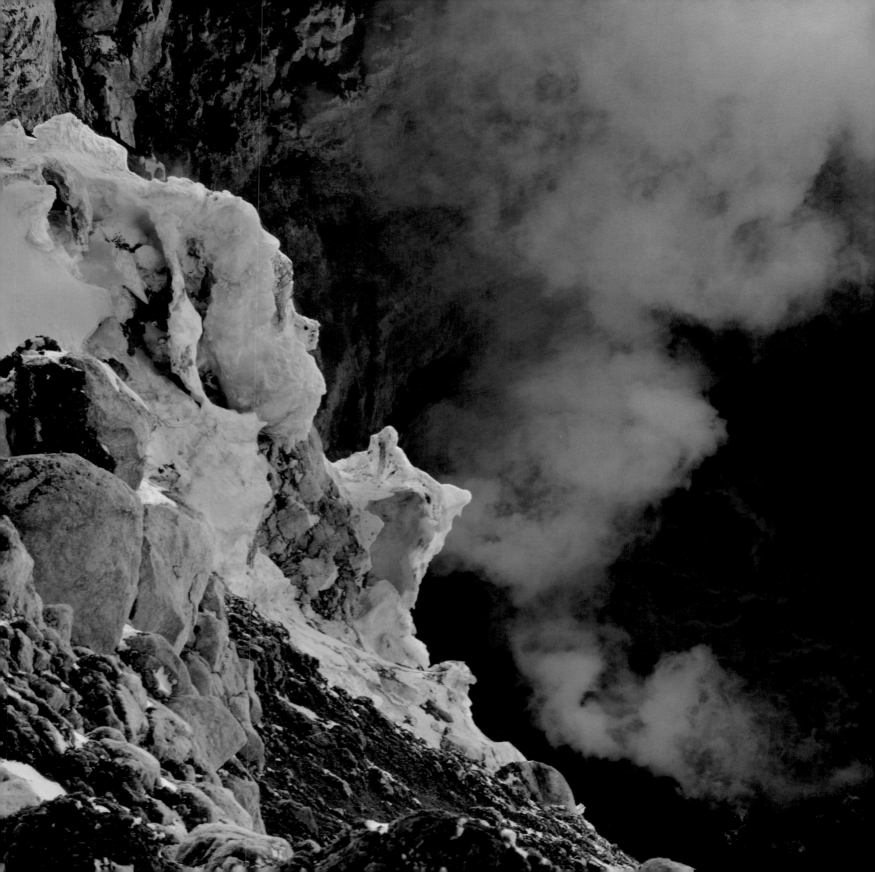

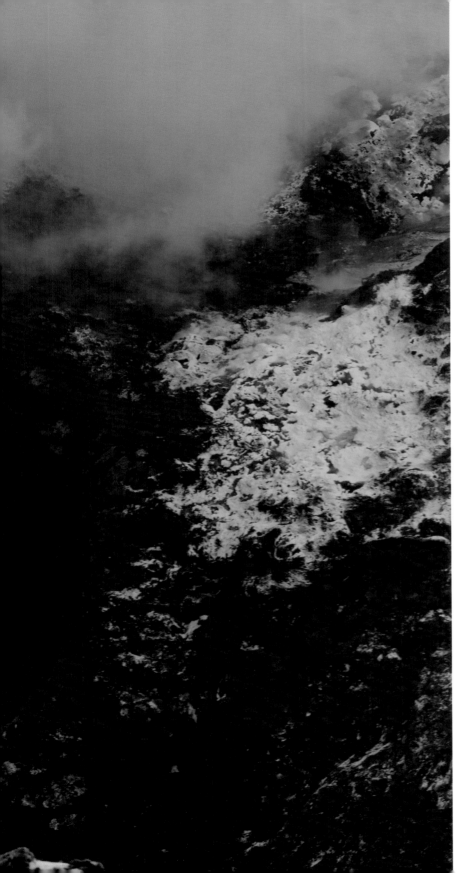

滾燙岩漿上方的冰煙囪
Ice chimney above boiling lava

南極洲，伊里布斯峰
Mount Erebus, Antarctica

伊里布斯也許是地球上最奇特的火山，眾多噴氣孔在冰冷的極地氣溫中形成形貌怪異的冰煙囪，有些甚至從溫度超過攝氏 1000 度的小熔岩湖都能望見。有時巨大的氣泡會往上噴，炸開湖面，而伊里布斯的火山結晶也隨之飛散到火山口周圍廣大的範圍內。

Mount Erebus is perhaps the most exotic volcano on the planet. Fumaroles become bizarre ice chimneys in the icy arctic temperatures. There are even some within sight of the small lava lake with temperatures of over 1000°C. Sometimes the lake explodes when huge gas bubbles shoot upwards. Then the volcano explodes and Erebus crystals fly in a wide radius around the crater.

白色煙囪
White smokers

南極洲，伊里布斯峰
Mount Erebus, Antarctica

火山側坡有些地方布滿了冰霜、噴氣孔和冰冷的陷阱。噴出
氣體和水汽的噴氣孔會結凍，形成由高塔和汽泡組成的冰冷
宮殿，難以通過，而有些結構非常薄，如果不小心踩破了，
不曉得會掉入多深的地方。

Some flanks of the volcano are covered with frosty excesses,
snorkeling and icy pitfalls. Fumaroles, where the Erebus spits
out gases and water vapor, freeze to an ice palace made of
towers and bubbles that cannot be easily penetrated. Some
formations are very thin and you can never be sure how
deep you might fall if you break through.

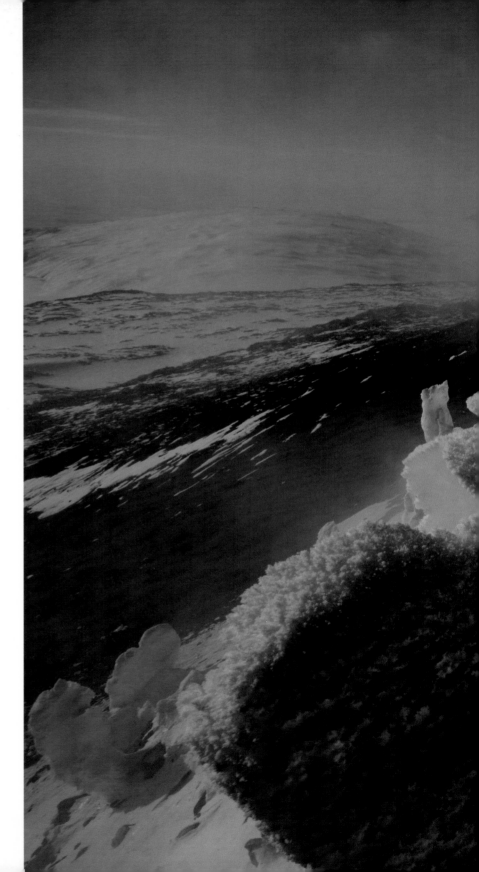

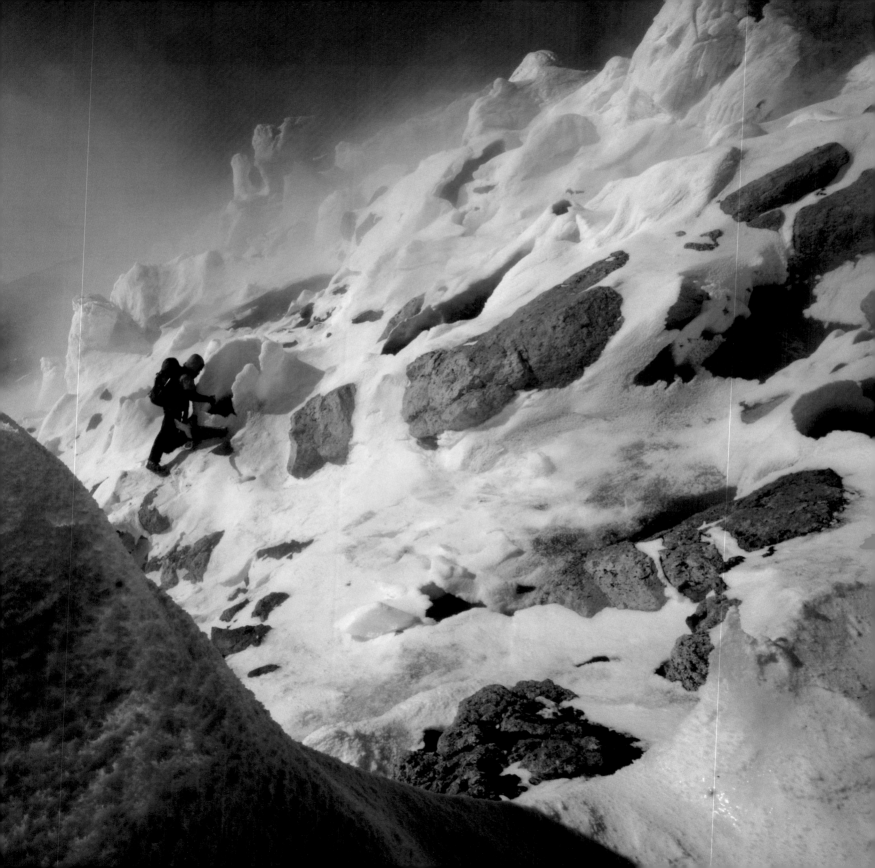

自然雕塑大師
Henry Moore was here

南極洲，伊里布斯峰
Mount Erebus, Antarctica

冰的形狀變化無窮，彷彿海浪在捲起的過程中被瞬間結凍。
若說這些傑作出自於雕塑大師亨利·摩爾之手也不為過，只
是它們不像真正的雕塑固定不變，而是持續變化，有時極為
迅速而劇烈。

The variety of forms has no limits, as if the ice acts like a
surf and freezes in shock-induced paralysis when rearing up
into waves. Henry Moore could have been here personally,
but the formations are in a permanent flow and sometimes
change quickly and dramatically.

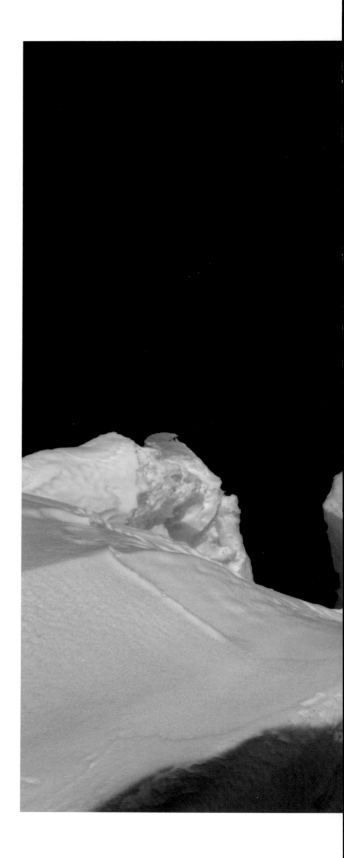

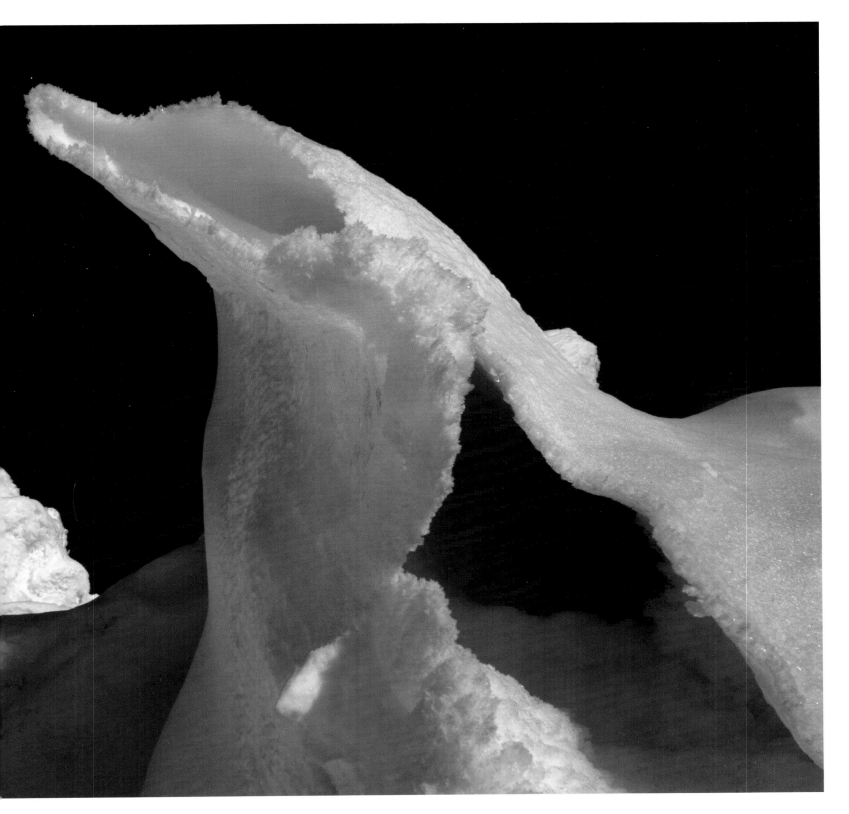

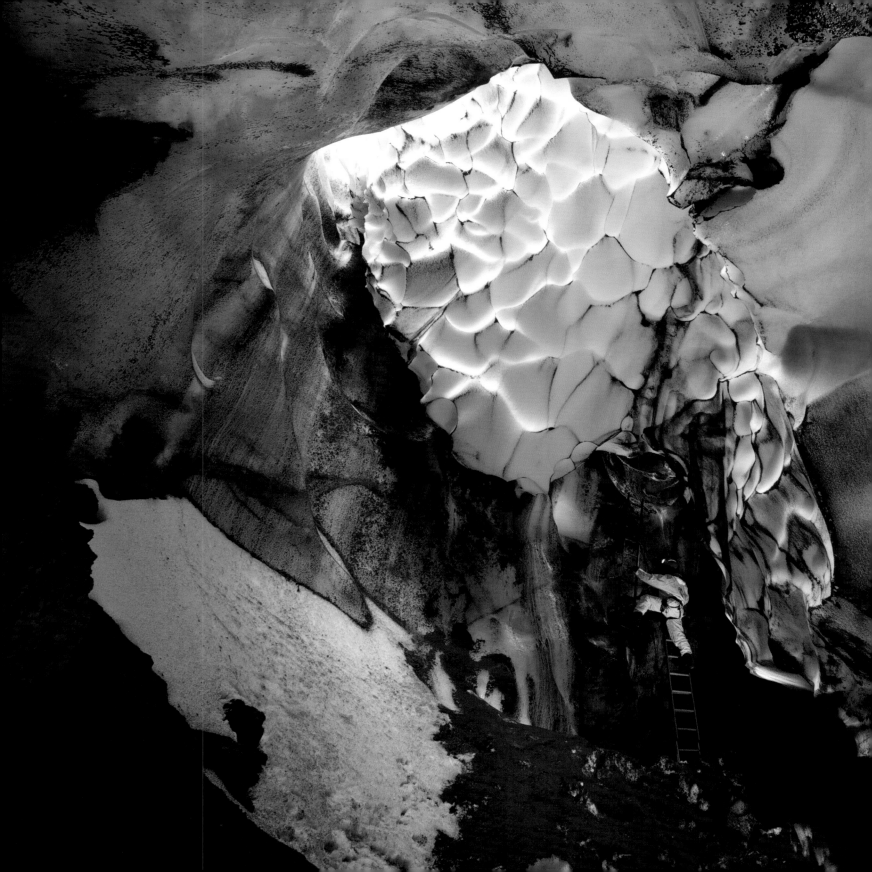

熱蝕冰川
Heat of the volcano

南極洲，伊里布斯峰
Mount Erebus, Antarctica

冰川被高溫侵蝕所形成的沃倫洞，是伊里布斯火山中最大的洞穴，可用梯子進入。在這片冰的宮殿內，冰壁被洞內暖空氣形成的氣旋雕刻出宛如磁磚般的花紋，處處可見盤子大小的冰晶，還可以仰看高聳的冰煙囪。

The Warren Cave is the biggest cave in the Erebus volcano and can be accessed via ladders into a glacier corroded by warmth. Huge tiled walls are scoured-out by air vortexes of moderately warmed up cave air. You enter into an ice palace with impressive jewelry made of saucer-sized ice crystals and you can see the ice chimney from below.

尋找嗜極生物
On the hunt for extremophiles

南極洲，伊里布斯峰
Mount Erebus, Antarctica

照片中，微生物學家克雷格·凱瑞正在冰穴內的地面採集樣本，對他來說，冰穴是通往岩石圈（地殼外部岩石層）的一扇窗。洞穴內演化出了驚人的微生物，並且可以採集到罕見的表面未受汙染的樣本，他因而發現了許多新的古菌。

The microbiologist Professor Craig Cary takes a sample from the ground inside the ice cave. For him, the caves are a window to the lithosphere, the upper rock strata of the earth. Inside them, an extraordinary microbiological life evolved and present a rare opportunity to obtain samples that are largely free of surface contaminants. He thereby discovered numerous new archaea.

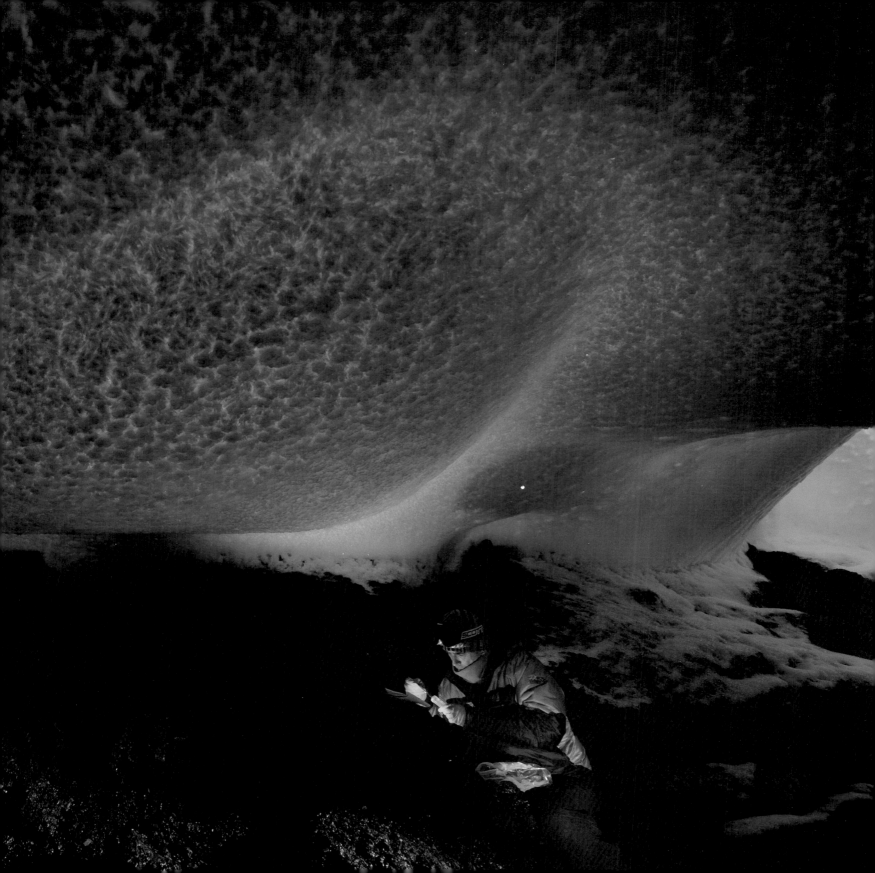

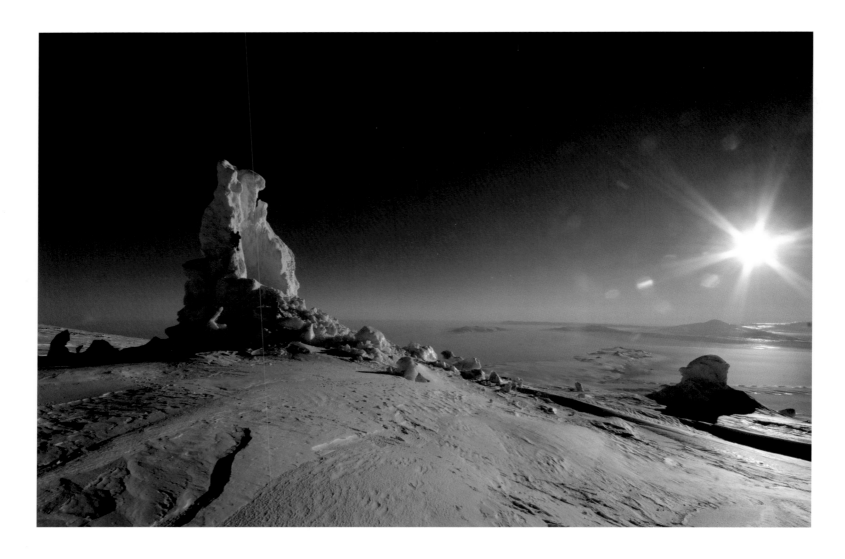

空心冰巨人
Hollow ice giants

南極洲，伊里布斯峰
Mount Erebus, Antarctica

有些氣井必須仰賴中空的高聳冰塔才能存在，只是這些冰塔不時會因自身的重量而坍塌，還必須承受有時會把它們吹倒的強烈暴風雪。圖中，探險隊員丹尼爾‧耶勒正在探索最高的一座冰塔，從那裡也可俯瞰南極大陸的景色。

Some gas wells rely on hollow towering ice giants, which sometimes collapse under their own weight. They have to withstand devastating blizzards that often mill them down. Daniel Jehle explores the highest of them, with a view over the Antarctic continent.

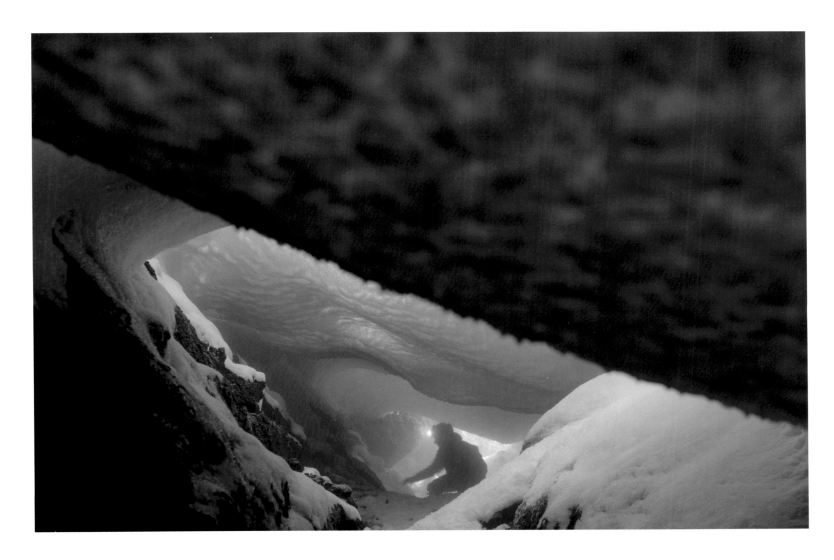

藍調暮光
In the bluish twilight

南極洲，伊里布斯峰
Mount Erebus, Antarctica

伊里布斯火山的邊緣散布著迷宮般的冰穴，穴頂有些地方很薄，陽光可以透進來。洞穴內的光線隨著冰層厚度有所不同，有些地方閃耀著天藍色，有些是深藍色的微光，有些則一片漆黑。

The volcano Erebus is interspersed at the edges with a labyrinth of ice caves. Some ceilings are so thin that light shines through. Depending on the thickness, everything shines in sky-blue or is immersed in the blue twilight or even total darkness.

洞穴搜祕
Caves

「**我熱愛**探索不同的自然環境、踏上非凡的探險發現全新事物。」

洞穴是自然界僅存的謎團之一，到目前為止人類僅探索過其中一小部分。身為洞穴探勘者，卡斯坦·彼得曾為《國家地理》雜誌拍攝過墨西哥的水晶洞穴、位於越南的巨大洞穴走廊，以及中國的超級洞穴。在陰暗潮溼的地底洞穴中拍攝有許多困難：不只缺乏自然光，還有會散射光線的霧氣，甚至有毒氣體。單純的拍照已經無法滿足彼得，他總是在追求自我挑戰，喜歡找出方法解決問題。試過各種打光方式後，彼得發現沒有任何一種單一手法能適用於所有狀況，一切取決於所在的環境。他發明了新的快門觸發裝置，能夠配合使用的相機點亮閃光燈；有些情況則須動用十幾人手持燈光以照亮巨大的洞室。「我總是在做不同嘗試，發現新的方法，這過程對我而言很有意思。」

"**I love** to explore new ranges of environment, and make extraordinary expeditions to discover something new."

Caves are among nature's last remaining mysteries, and only a small number of them have been explored. As a caver, Peter photographed the Cave of Crystals in Mexico, the large cave passage in Vietnam, and the super caves of China for National Geographic magazine. There are many difficulties when shooting in the dark, damp tunnels: The lack of natural light, diffusing fog and even toxic gases. Plain photography is not enough for Peter, he always seeks personal challenges and enjoys figuring out problems. Having used all sorts of lighting technologies, Peter found that no distinct way is appropriate for all situations, it always depends on the environment. Peter constructed a personal trigger device which is capable of igniting bulbs according to the camera used; while other times he may need more than a dozen people to light up the giant cavern. "I always experiment and discover some new ways; that's interesting to me, to come up with something new."

越南，韓松洞

Son Doong Cave, Vietnam

你能想像在洞穴裡面有一片叢林嗎？韓松洞，又稱山水洞，是越南廣平省峰牙－己榜國家公園內的洞穴。韓松洞在1991年被當地人發現，英國洞穴研究協會於2009年前往勘查後，描述了一座巨大的洞穴，彷彿地底下的聖母峰。韓松洞是峰牙－己榜國家公園內150個洞穴中最大的洞穴走廊，也是目前世界上已知截面積最大的洞穴走廊，寬170公尺，長5.5公里，高約200公尺，可輕鬆容納一架747飛機或是一整排40層樓的大樓。韓松洞是由河流流過石灰岩層、並沿著一條斷層往下溶蝕而成，在山區下方逐漸形成了龐大的地下通道。石灰岩層鬆軟的地方則崩垮成巨大的天井。除了高達十層樓的石筍和石灰華階地，韓松洞裡還有一片濃密的叢林，以及一條地下河。

Can you imagine a jungle inside a cave? Son Doong Cave, also known as "Mountain River Cave", is located in Phong Nha-Ke Bang National Park in Quang Binh Province, Vietnam, and was first discovered by locals in 1991. The British Cave Research Association conducted a survey of Son Doong Cave in 2009, and described the discovery of a cave so big that it was like finding a previously unknown Mount Everest underground. Son Doong Cave is the largest cave passage within the national park, which is a network of over 150 caves. It is also the largest known cave passage cross-section in the world, with a height of about 200 meters, width of 170 meters, and length of 5.5 kilometers. It can comfortably fit a 747 airplane or an entire New York City block of 40-story buildings. Son Doong Cave was formed by river water flowing across the limestone, burrowing down along a fault, scouring out a giant tunnel beneath the mountains. The soft parts of the limestone collapsed, creating skylights. Its unique formations include stalagmites that are more than ten stories tall, stalactite terraces, a dense jungle, and an underground river.

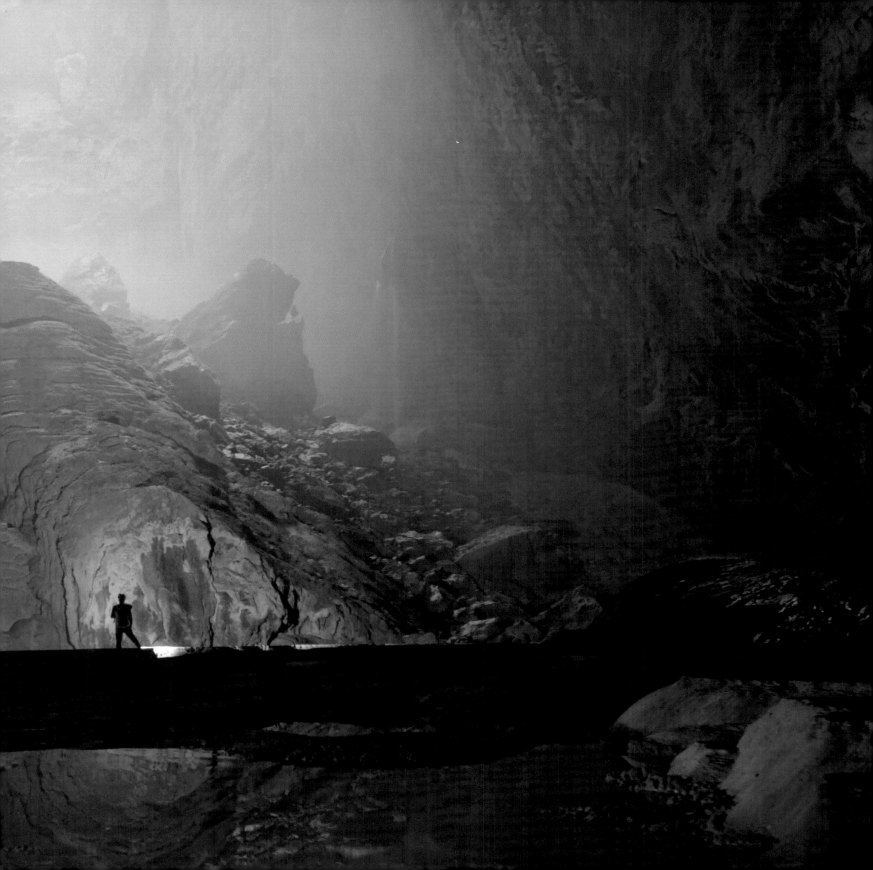

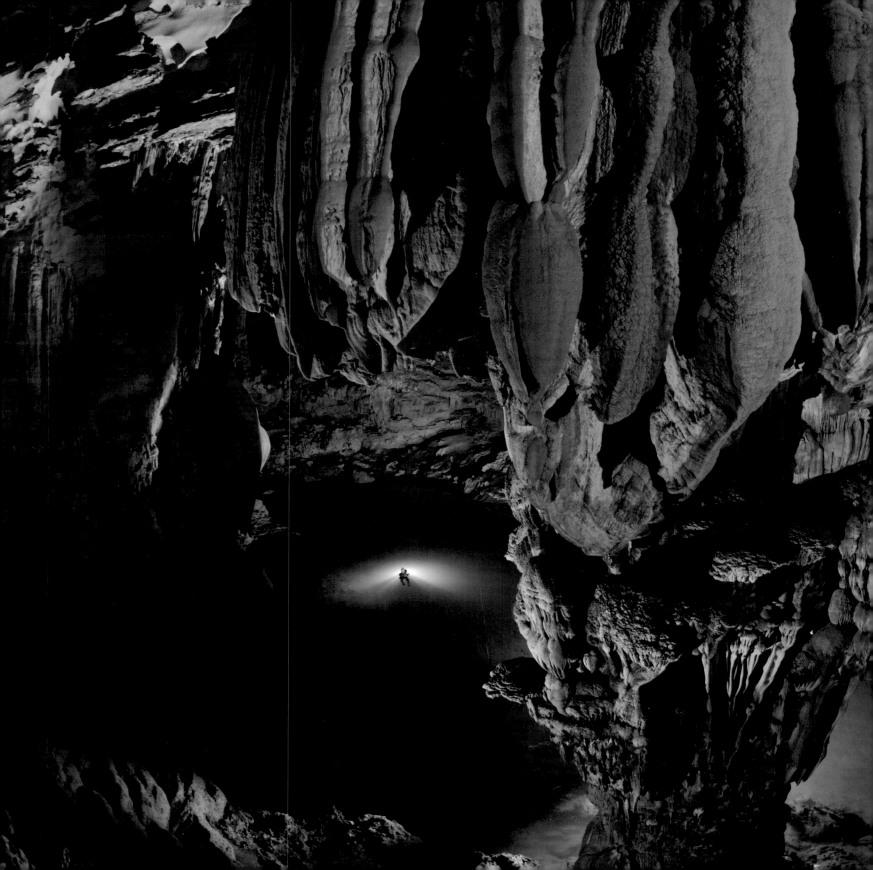

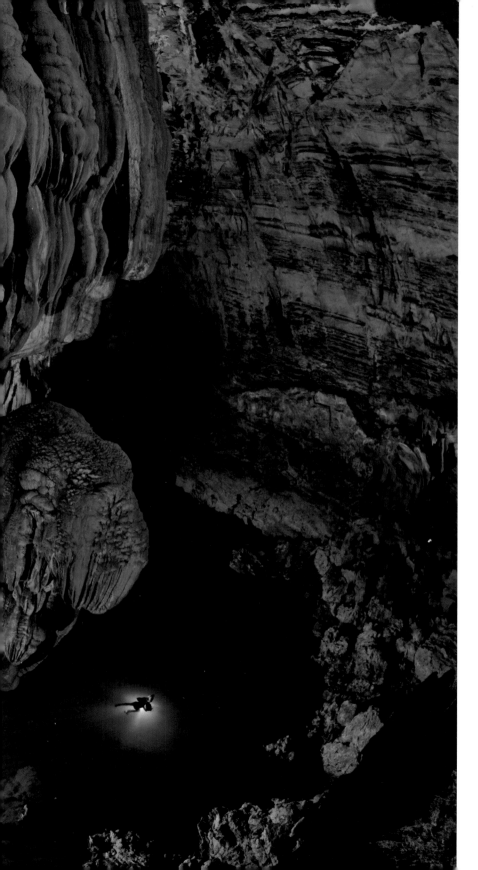

綠色眼睛
Green Eyes

越南，韓松洞
Son Doong Cave, Vietnam

這是一座新發現的水下洞穴，從附近的一處平臺上拍攝。來到這個洞穴，可以在夢幻的鐘乳石群和水道間游上 1 公里，有時還會碰上轟然流瀉的瀑布，只是一路上都會不斷受到昆蟲大軍騷擾。

A newly discovered underwater cave, photographed from a nearby balcony. Here you can swim for over a kilometer through a fantastic land of stalactites and waterways, sometimes encountering thundering waterfalls, but always tormented by an army of insects.

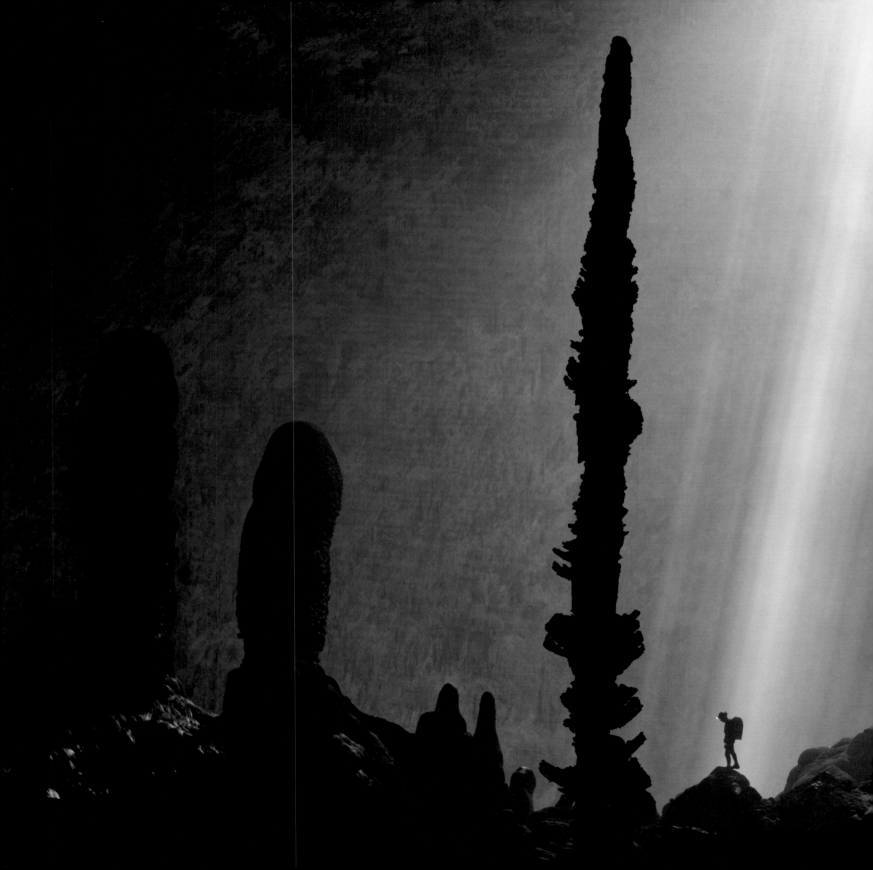

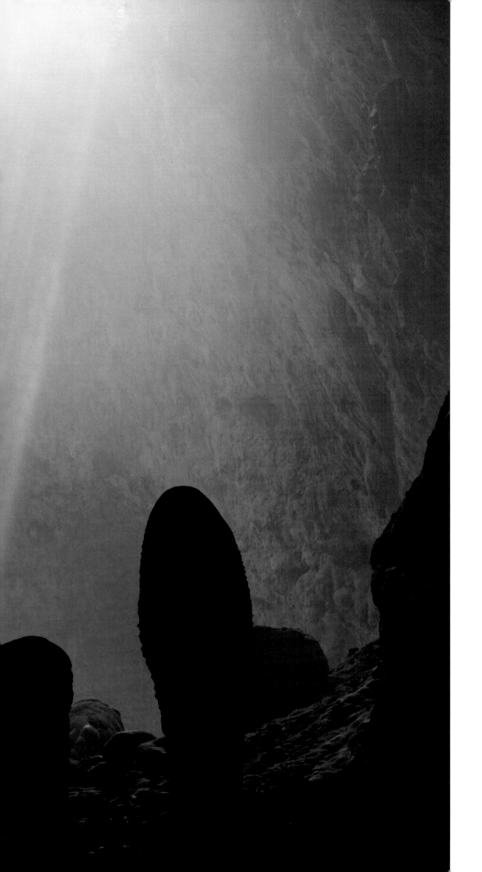

仙人掌花園
Cactus garden

越南，韓松洞
Son Doong Cave, Vietnam

長相奇特、宛如棕櫚樹幹的細瘦石筍在一片杵狀滴水石中鶴立雞群。這個全新發現的洞穴被命名為「仙人掌花園」，距離韓松洞只有一個鐘頭的路程，兩個洞穴很有可能是相連的，但至今尚未找到通道。這裡經常繚繞著美麗的雲霧。

A bizarre, thin palm trunk stalagmite dominates the accumulation of clubbed dripstone formations. It is a new discovery and wonder that the world called "cactus garden". The sunlit cave room is only an hour away from Hang Son Doong, and it is possible that the two caves are connected, although the passage hasn't yet been found. Wonderful swirling cloud formations often arise here.

無盡的光束
Endless Beam

越南，韓松洞
Son Doong Cave, Vietnam

洞穴是地球上僅存的謎團，至今人類只探索了一小部分。然而 2009 年迎來了一項重大發現：探洞者找到擁有巨大通道的韓松洞，彷彿發現了地底的聖母峰。高功率的 LED 光束消失在龐大的洞穴內，總共需要 14 個人合作，才有辦法照亮這條長度超過 1 公里的走廊。

Caves are the last great mysteries of our planet. Only a small percentage have been explored. But 2009 marked a sensational find: The discovery of what could be described as a Mount Everest underground, with colossal corridors of an unknown dimension.The strong light beam of a high performance LED disappears in the huge cove of the Son Doong Cave. Fourteen people were needed to illuminate the mile-long corridor.

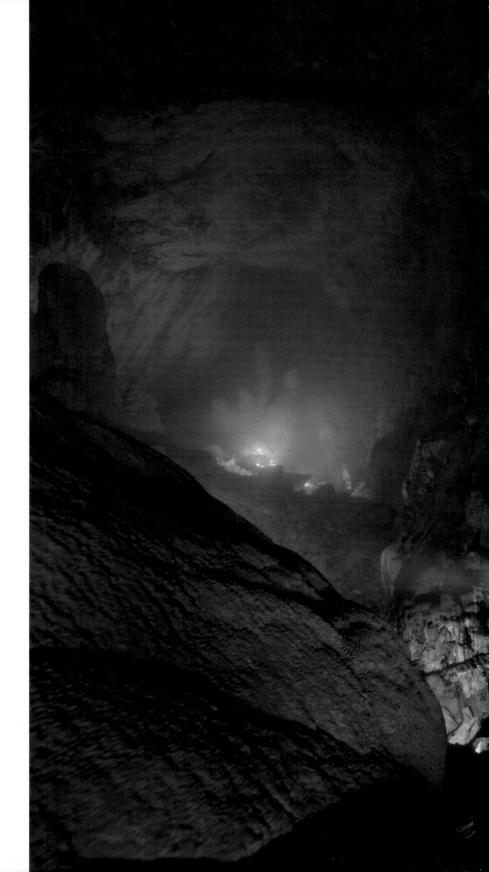

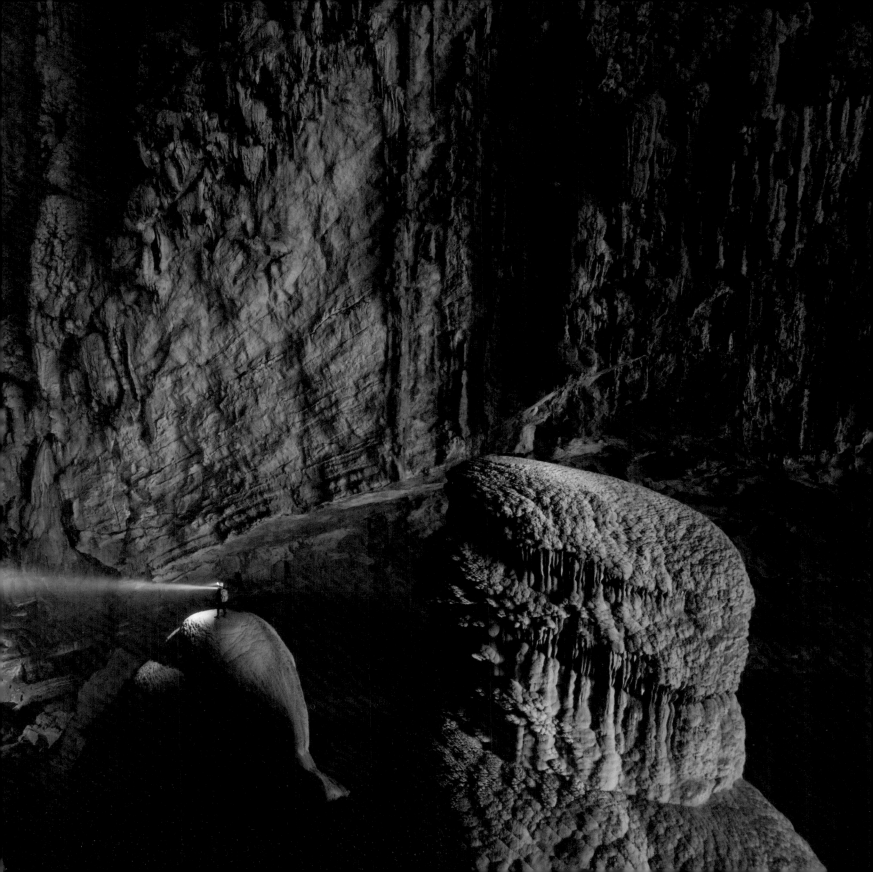

華美的階梯
Maybe the most beautiful staircase

越南，韓松洞
Son Doong Cave, Vietnam

在第一個天井透入的光線下，遼闊的泉華凹槽蜿蜒形成美麗的階地，藻類織成的綠色地毯覆蓋著溼潤的石灰岩壁。不幸的是，韓松洞正面臨嚴重威脅：一條長 10 公里的纜車軌道將把洞穴開放給大眾觀光。

Sweeping sinter basins meander like fantastic balconies in the hollow light of the first shaft opening. A verdant carpet of algae settled on the moist limestone cliffs. Unfortunately the Son Doong Cave is highly endangered at the moment: A 10 kilometer cableway will open her up to mass tourism.

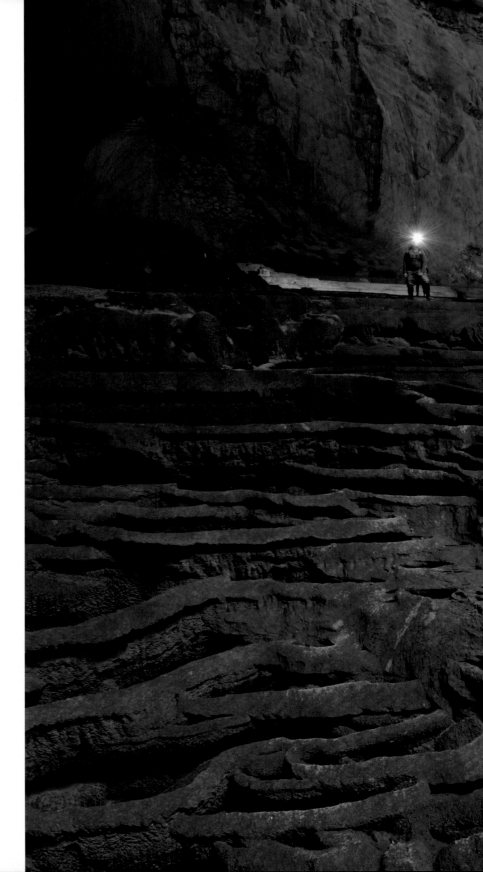

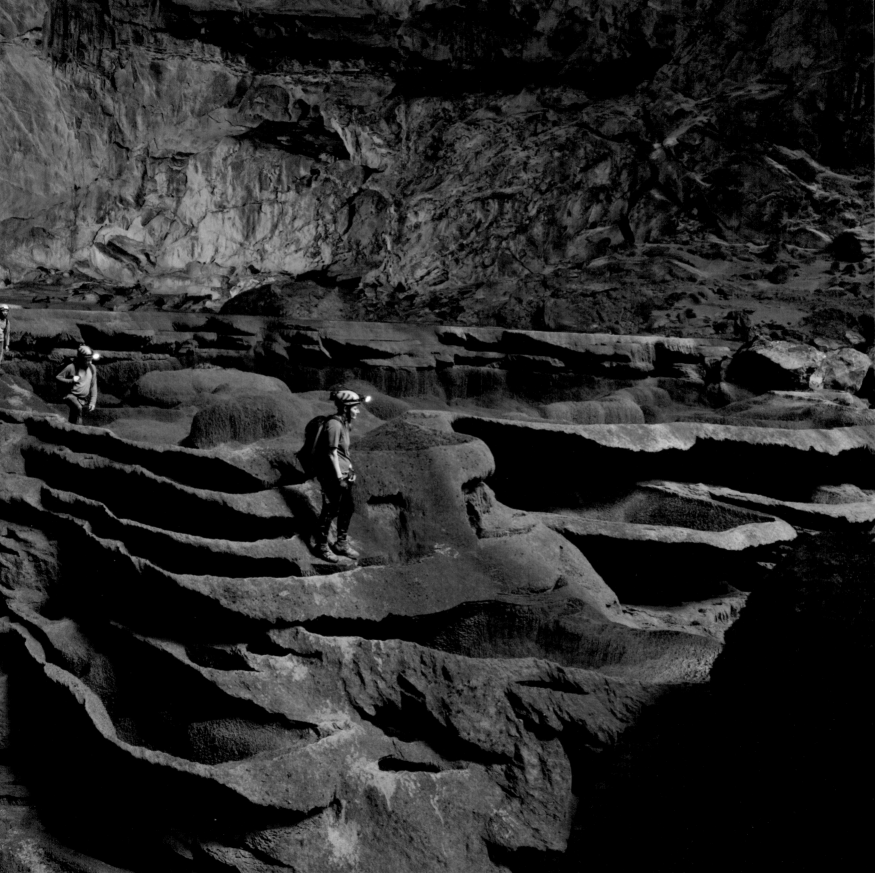

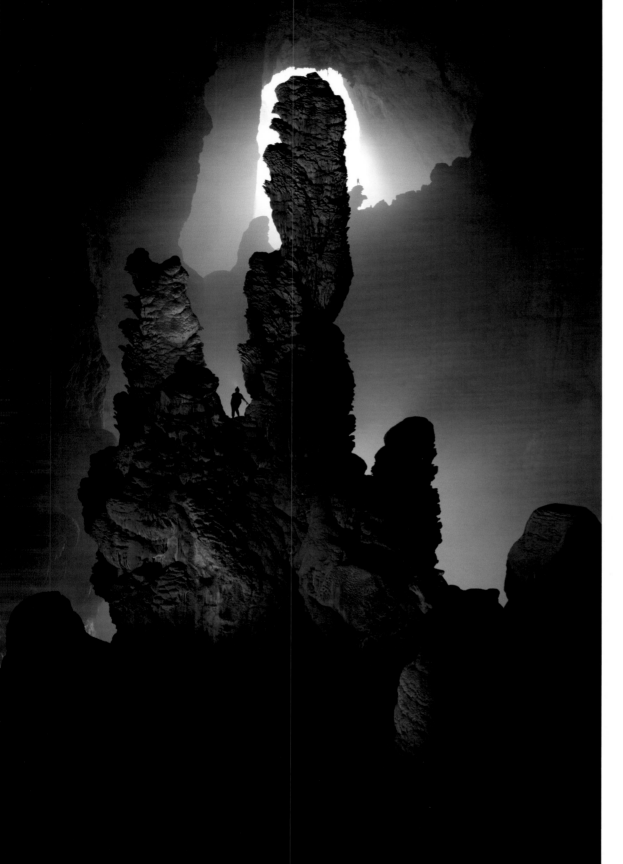

15 樓的景色
View from the 15th floor

越南，韓松洞
Son Doong Cave, Vietnam

韓松洞內的鐘乳石高聳參天：洞穴研究者黛博·林伯特站在相當於 15 層樓高的地方，俯瞰深邃的洞穴。如果她的照明設備可以照亮下方深處，她會看到堆積了一整片的碎屑，全是從洞頂掉落的大塊石頭。她的工作夥伴站在泉華石柱上，離她大約 800 公尺，只能透過無線電聯絡。後方刺目的光芒來自大約 1.5 公里外的第一個天井（滲穴）。

Stalactites reach gigantic proportions here: At a height equivalent to the 15th floor, cave researcher Deb Limbert looks into the depths of the noble arch. If she could cast a light down that far, she would be looking over a field of debris: over block materials that have broken off from the ceiling. Her colleague on the sinter figure is about 800 meters away and can only be reached with a radio set. The light from the first sinkhole (shaft opening) is blinding from about 1.5 kilometers away.

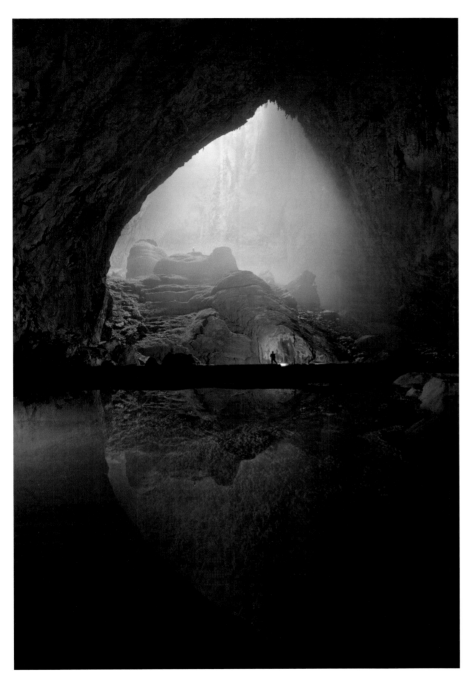

「恐龍出沒！」
"Beware of the Dinosaurs!"

越南，韓松洞
Son Doong Cave, Vietnam

這是英國探洞隊成員為這座滲穴所取的名字，因為這裡的景色有如電影《侏羅紀公園》的場景，即使突然跑出一隻恐龍也不讓人意外。暴風雨讓泉華凹槽注滿了水，平靜的水面映照著上方宛如堡壘的石灰華構造，與水下的石灰華結晶相映成趣。

This is what the English cave researchers dubbed the sinkhole. The scenery was like a "Jurassic Park" movie set; not even a dinosaur would surprise you here. Storms filled this huge sinter basin in which the fortress-like tufa formations are reflected. The reflection merges with the crystalline calcareous sinter under the water.

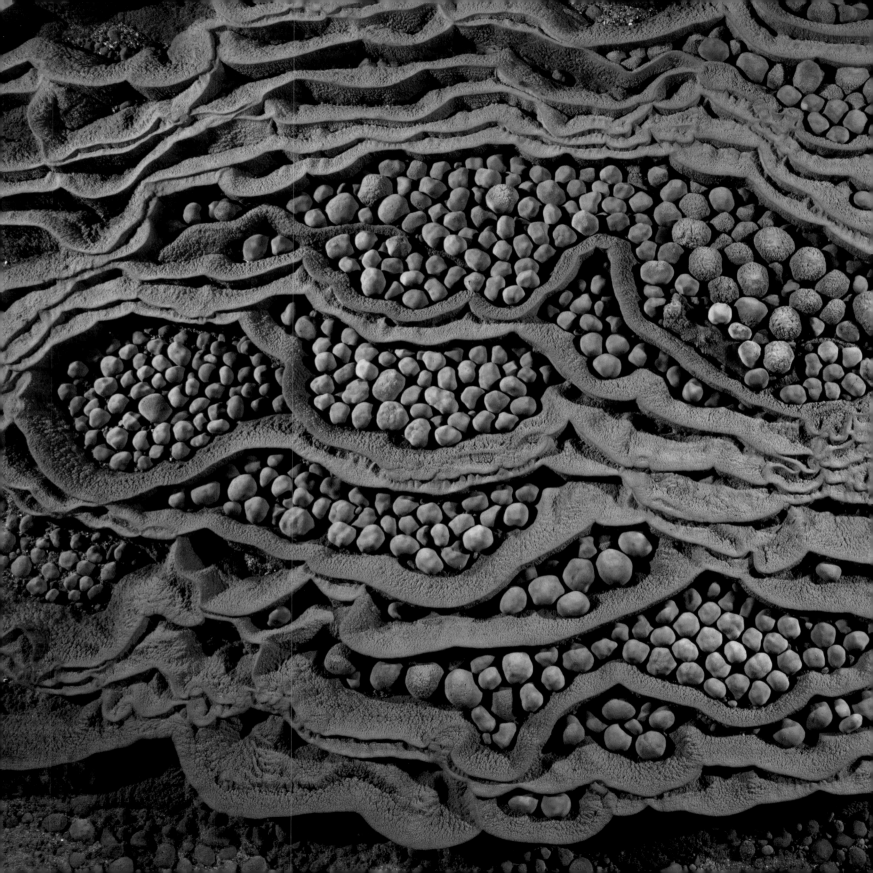

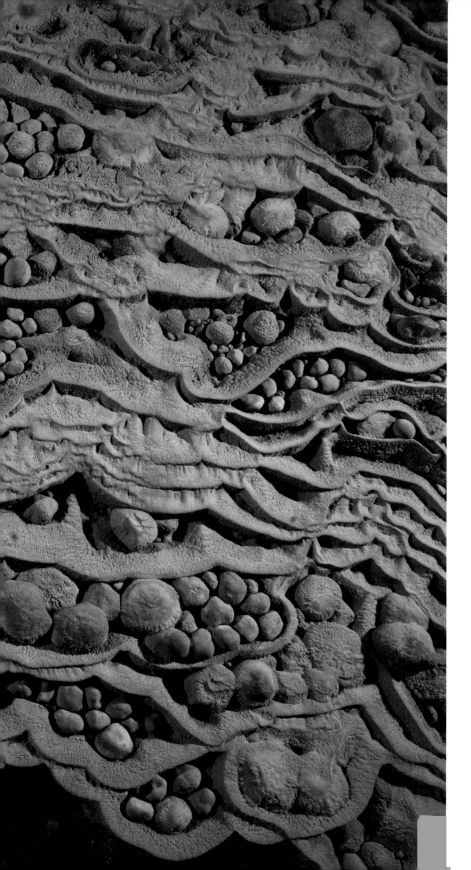

洞穴珍珠串
Cave pearls en masse

越南，韓松洞
Son Doong Cave, Vietnam

石灰華或文石會一層又一層地沉澱在一顆砂粒上面，長年累積形成美麗的穴珠。每顆穴珠都坐落在自己的「巢」裡面，由洞頂一滴滴落下的水滴緩緩將它們塑造成更圓潤的珍珠。

Calcareous sinter or aragonite deposits itself layer after layer around a grain of sand. Over decades and centuries, they grow into a beautiful cave pearl. All of them sit in their own "nests" and droplet after droplet from the ceiling will turn them a little bit more into pearls.

洞穴裡的森林？
A forest in a cave?

越南，韓松洞
Son Doong Cave, Vietnam

韓松洞位在地球上最古老的喀斯特地形區之一，發展時間歷時 4 億年。期間，有些巨大的走廊與洞廳因為太過巨大，靜力平衡受到破壞，洞頂因而崩塌。在這些走廊與洞廳的廢墟中長出了奇特的叢林，渴望光線的植物在透進陽光處生長。

400 million years and one of the oldest karstic zones on earth gave the cave an extremely long period of development. Some corridors and halls were so big that their static force was undermined and the ceilings collapsed. On their ruins, a strange jungle spread in the twilight where gaunt plants crave light.

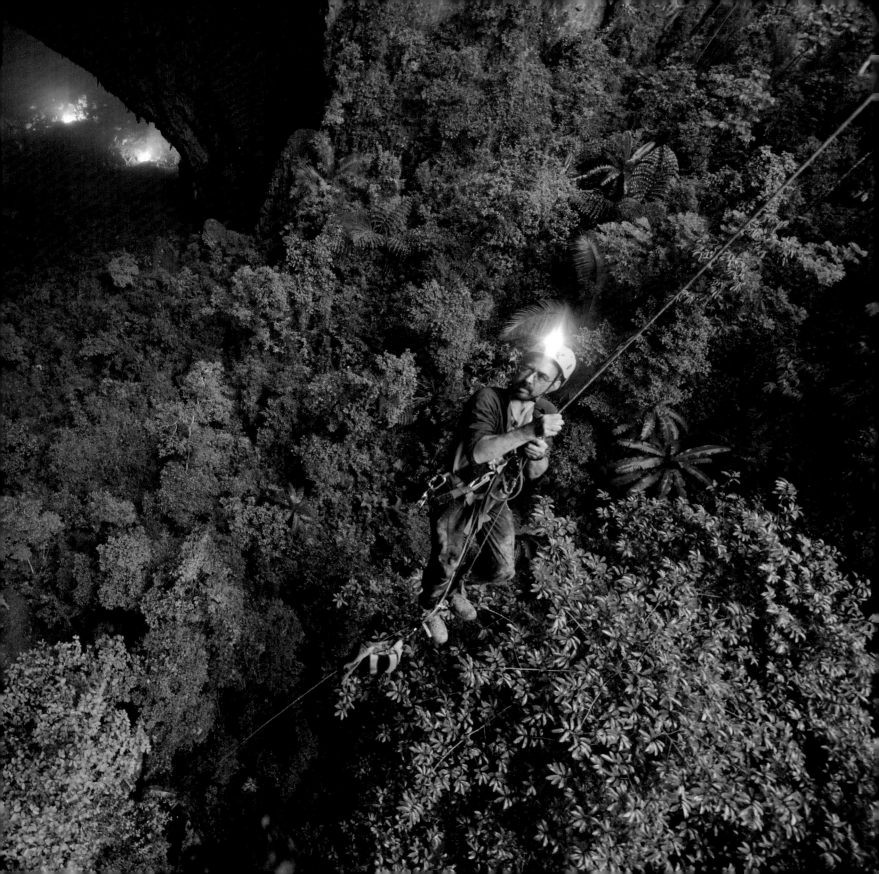

中國洞穴
Caves of China

廣西省與貴州省地下厚厚的石灰岩層中，隱藏著世界上最大的幾座洞穴，《國家地理》雜誌的專題報導稱它們為「超級洞穴」。苗廳位在巨大的格必河洞穴系統內，是世界上已知容積最大的洞室。1989年，中國與法國的聯合考察團隊首次記錄下這座龐大的石灰岩洞穴。2013年由國家地理學會組織的團隊再次前往苗廳，運用精密的3D雷射掃描儀，以前所未有的精細度進行測量。測量結果經研究者處理分析後，確認了苗廳的容積為1078萬立方公尺，比先前擁有世界上容積最大洞室頭銜的馬來西亞砂拉越洞還多了10%。

Beneath the thick limestone layer in Guangxi and Guizhou Provinces lies some of the largest caverns in the world, which National Geographic magazine dubbed "Super Caves". The Miao Room is part of the immense Gebihe cave system, and the largest known cave chamber by volume in the world. It was first documented by a joint French and Chinese survey team in 1989. A National Geographic team revisited Miao Room Cavern in 2013, using advanced 3-D laser scanners to measure the cave systems in unprecedented detail. The researchers reprocessed those scans and determined the cavern's volume to be 10.78 million cubic meters, exceeding the previous title holder—the Sarawak Chamber in Malaysia—by 10 percent.

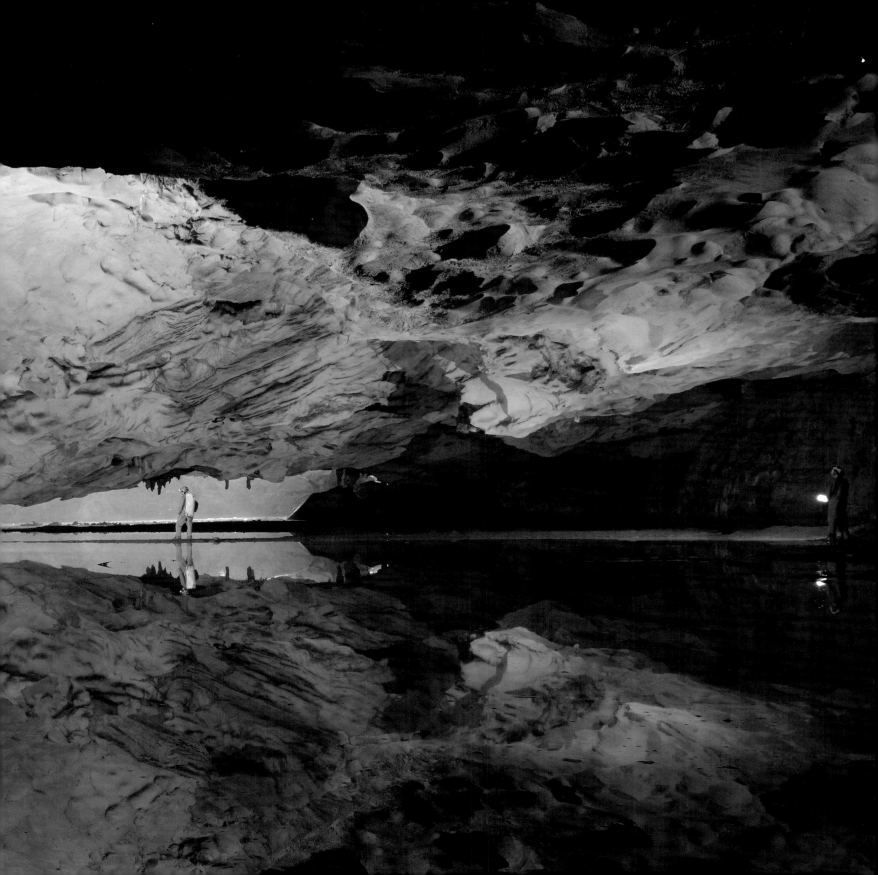

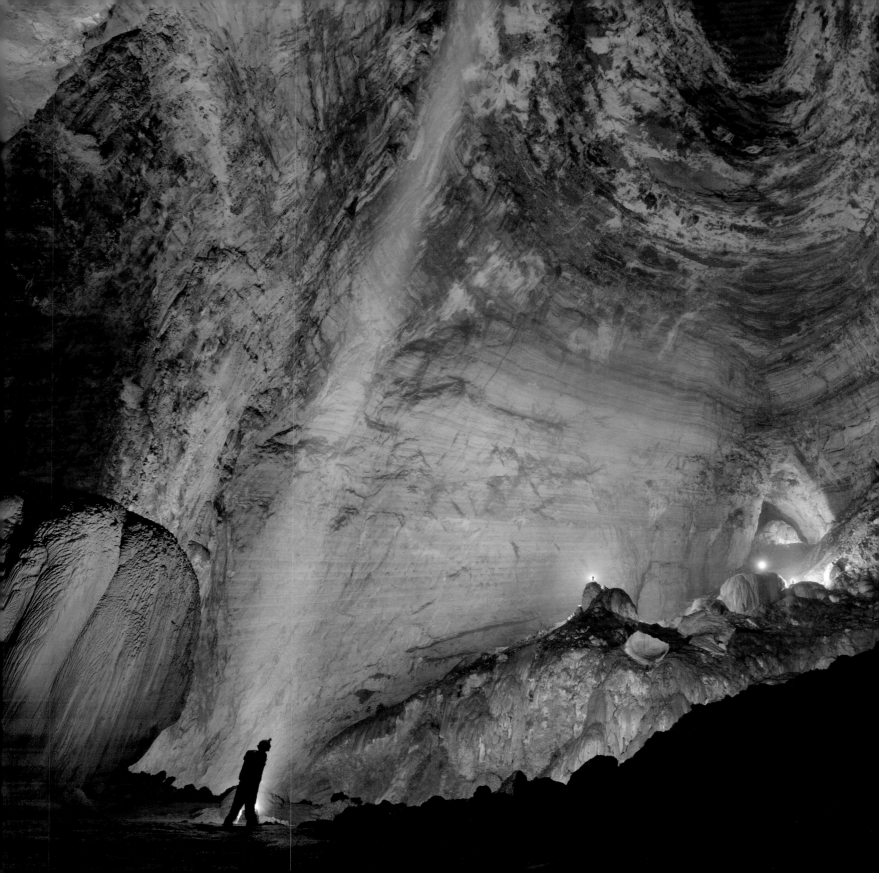

巨大的空洞
Gaping void

中國，樂業
Leye, China

紅玫瑰洞規模龐大，無法以一般燈具打光，只能用極強的閃光燈，在極短的時間內照亮整個洞室。這張照片具體呈現攝影師對洞穴的印象。持續降雨在前景的洞頂形成瀑布；在遠方背景處站立的人旁邊是掉落的鐘乳石，鐘乳石掉落後留下的空隙讓洞頂彷彿裂開的頭骨。

The enormous Hong Meigui chamber cannot be illuminated with normal lights, and for photographer Carsten Peter, the photo is an impression which he has never been seen before. Only extreme flashes can brighten the entire chamber for a fraction of a second. The continuous rainfall created a waterfall from the ceiling in the foreground, and next to the people far in the background is the fascinating fallen stalactite, separating the upper ceiling like an open skull.

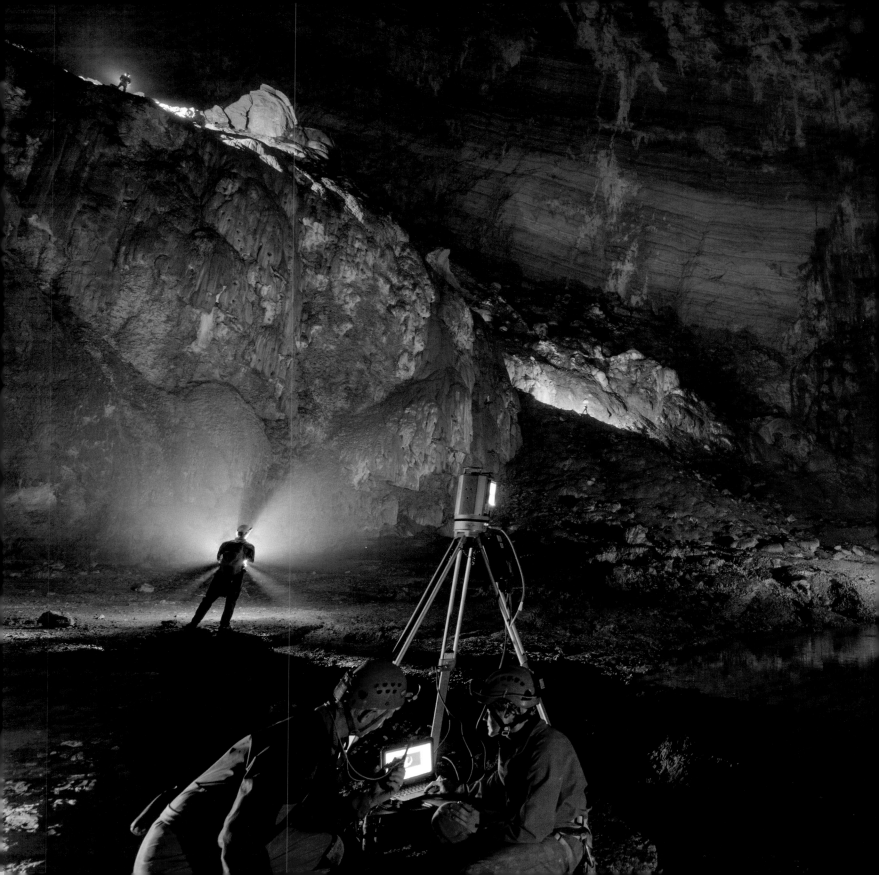

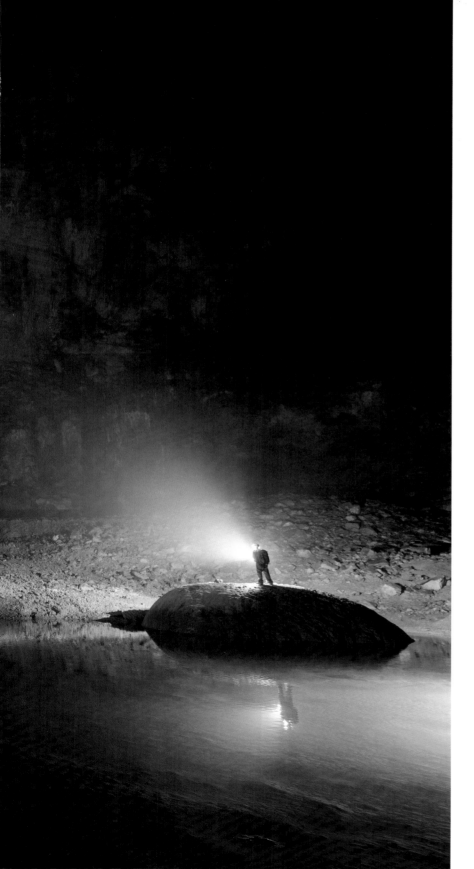

3D 掃描巨大的洞廳
3D scan of a gigantic hall

中國，樂業
Leye, China

探險隊將高性能的 3D 雷射掃描器帶進洞穴，這是史上第一次，標誌著後勤技術的進步。照片中，義大利隊員丹尼雅拉·帕尼和英國隊員安迪·伊佛斯正在測量全世界最大的洞穴之一：紅玫瑰洞。探險隊總共花了三天、使用 14 個測量點，才用數位化方式以高解析度重建出這座洞穴。

It was the first time that a high-performance scanner was brought into a cave, which marked a logistical achievement. There, Daniela Pani from Italy and Andy Eavis from England measure the Hong Meigui chamber. It is also regarded as one of the biggest on the planet. It took 3 days and 14 measuring points to digitally resurrect the chamber to a high-resolution virtual cave.

最大洞室
Hollow earth

中國，格凸
Getu , China

長 852 公尺、最高處 190 公尺的苗廳原本被認為是世界上第二大的洞室，但是這一點在英國遠征隊利用先進的 3D 掃描儀進行測量後有了改變。驚人的測量結果顯示：以容積而論，苗廳是地球上最大的洞室。

The Miao chamber was regarded as the second biggest cave hall in the world - with 852 meters in length and up to 190 meters high- until it was measured in this expedition by a British team with an advanced 3D scanner. The result was surprising: In terms of volume, it is the largest hall on earth.

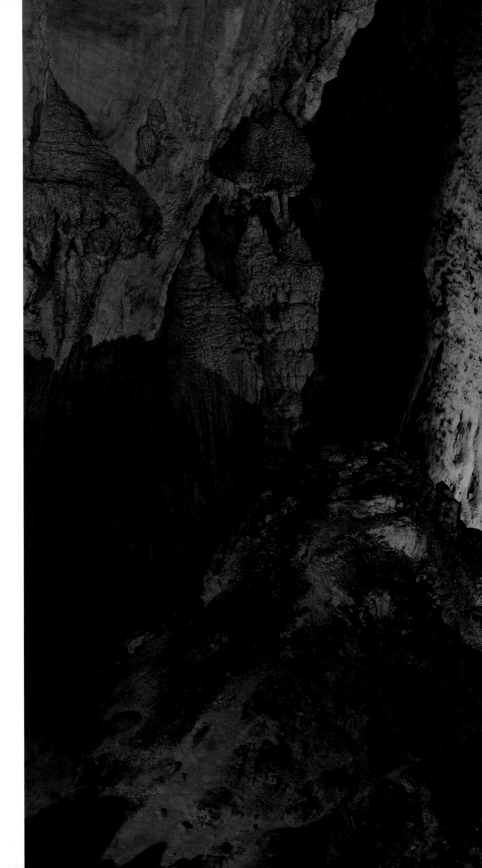

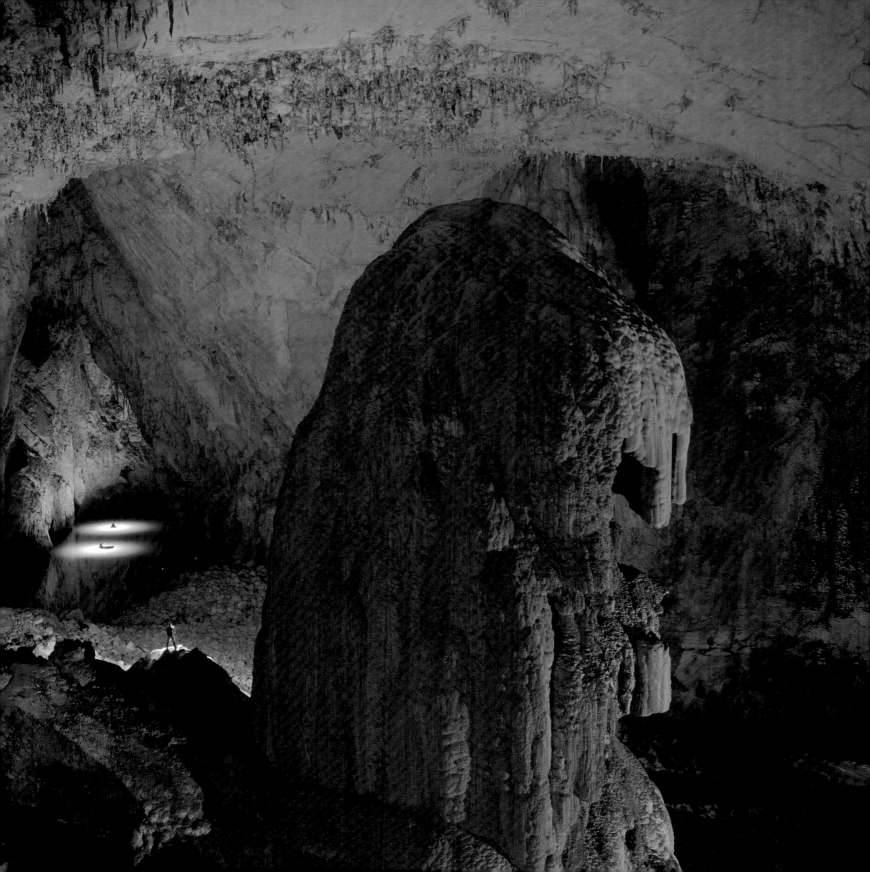

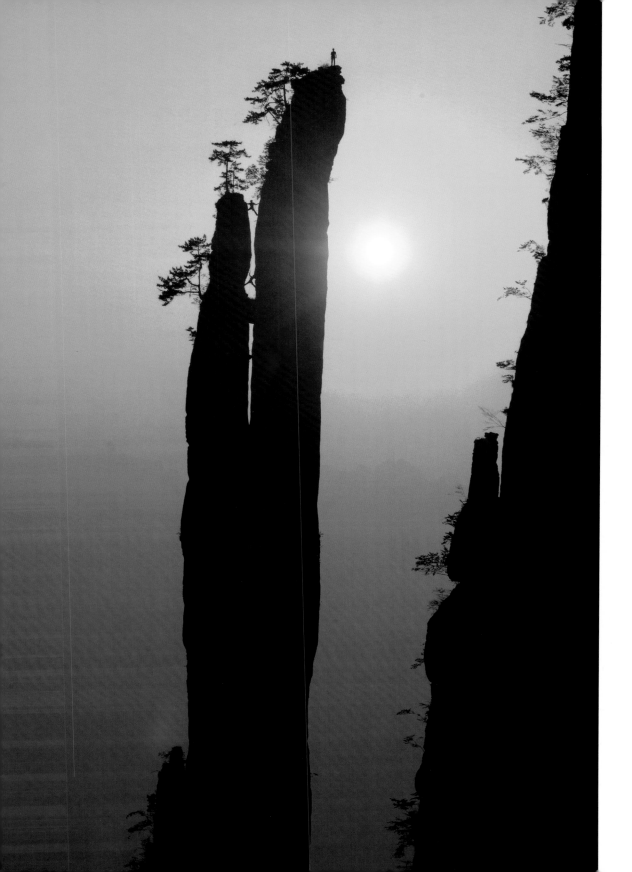

石灰岩峰的日出
Rising sun on the limestone spire

中國，恩施
Enshi, China

探險隊在為期多日的攀登後，完成了恩施大峽谷中高 140 公尺的石灰岩峰首攀。這座岩峰是喀斯特地形的一種，從中間一分為二形成饒富趣味的煙囪狀，再往上形成最主要的塔柱。顯然不怕高的探險隊員席德·萊特站在岩峰上。

The 140 meter high limestone spire in the Enshi Canyon was scaled for the first time in a multi-day climb. The rock tower, a unique karst formation, splits itself into an interesting chimney. From there, it goes to the main overhanging finger, where Cedar Wright stands and is apparently not afraid of heights.

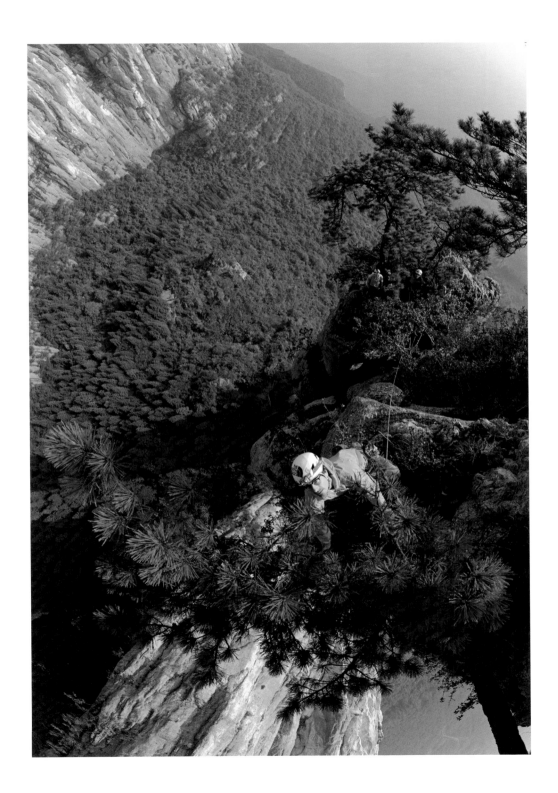

絕壁天懸
Sudden depth

中國，恩施
Enshi, China

探險隊員席德·萊特正在攀爬「母子峰」石塔的最後幾公尺，另外兩位隊員艾蜜麗雅·哈林頓和馬特·席格在「子峰」上幫他做確保。在光禿且陡直的石塔上竟有樹木生長，令人稱奇。來這裡攀岩最大的困難之一是取得許可，因為許多人擔心石塔會崩塌。

Cedar Wright climbed the last few meters of the "mother & child" rock tower. Emilia Harrington and Matt Segal stand on the "child" and secure him from there. How the trees steady themselves on the naked and sharply falling rock was absolutely amazing. One of the main problems the climbers encountered was getting a permit - people feared the towers might collapse.

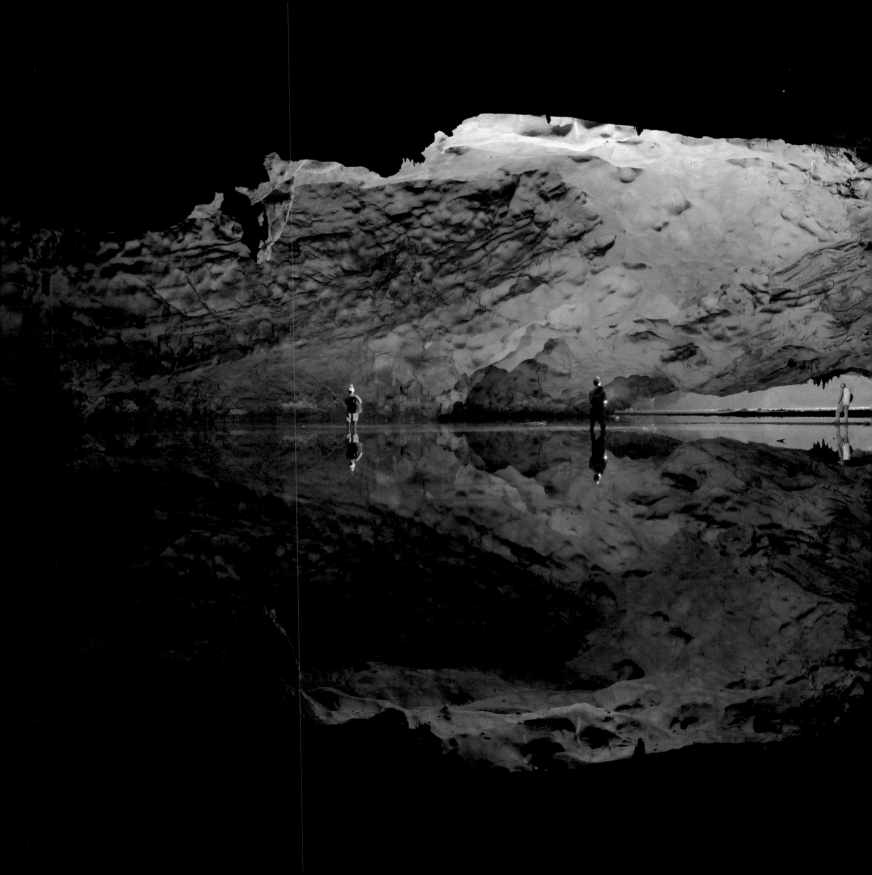

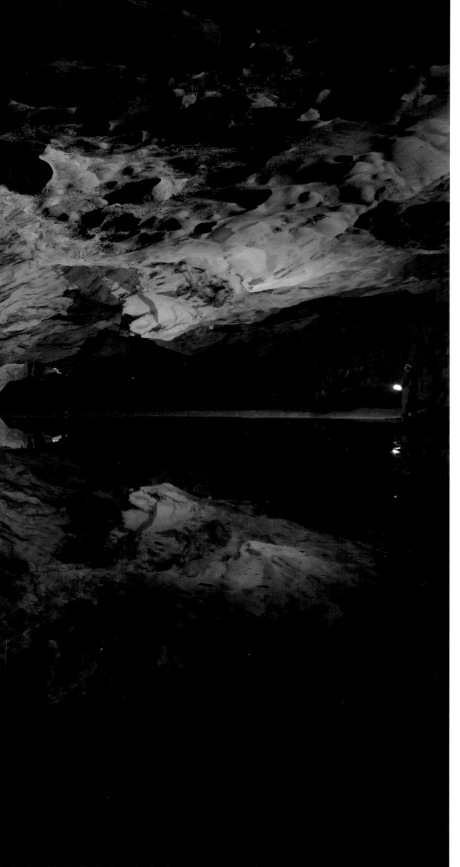

泰坦通道
Titan hallway

中國，樂業
North of Leye, China

這個平坦、淹著水的入口通往另一個龐大的洞室：泰坦神之房。下了將近一個月的雨之後，泰坦通道盈滿了水，平靜的水面就像一面鏡子。倒影讓這個通道看起來比實際大了一倍，但和接下來的洞室一比，仍然相形渺小。

This is the flat, flooded entrance to another huge chamber - "Titan chamber". It rained for almost a month and the undisturbed water surface spreads like a natural mirror. The passage looks twice its size because of the reflection, but it is tiny compared to the much bigger hall followed by a deep shaft.

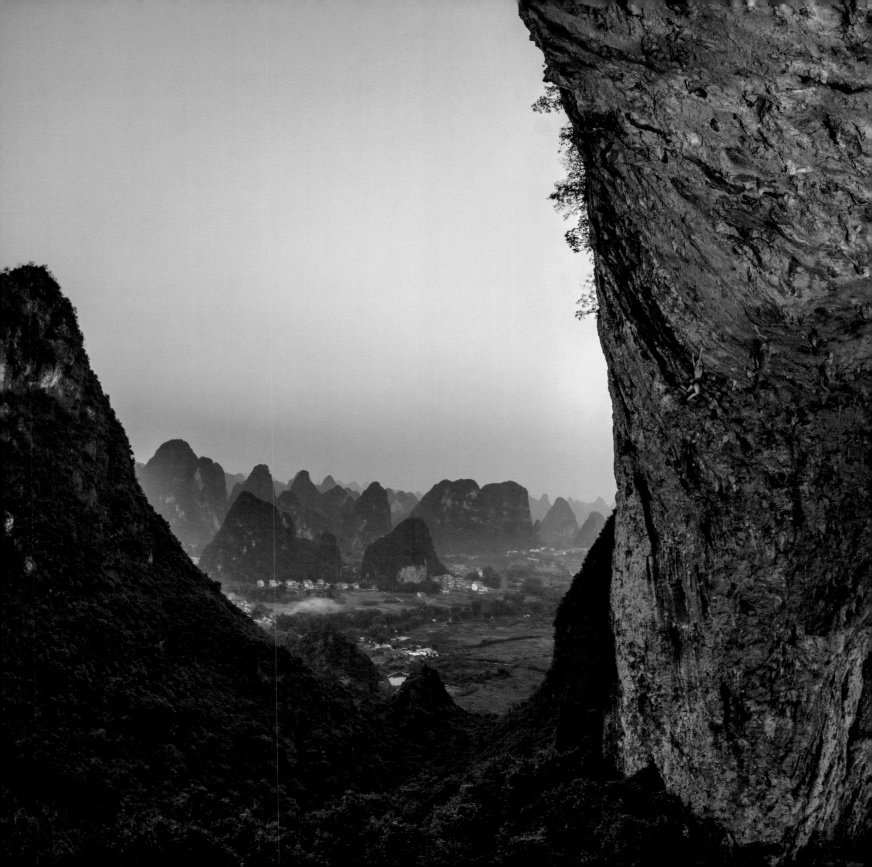

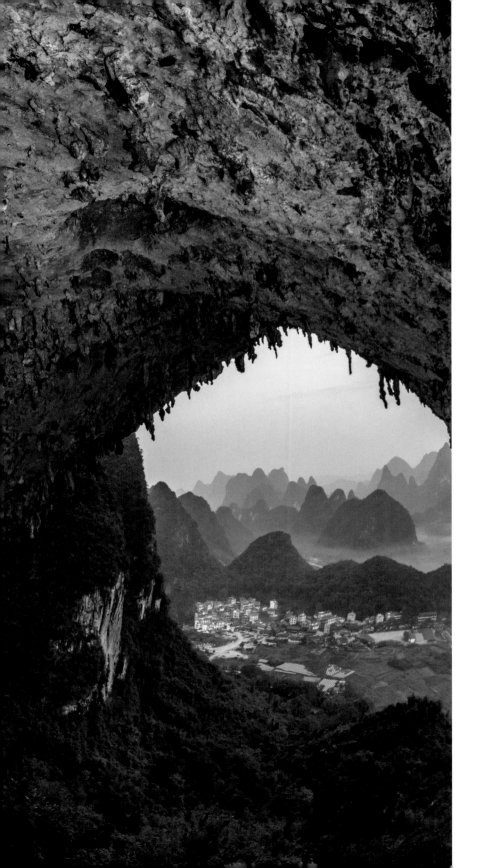

月亮山
The moon hill

中國，陽朔
Yangshuo, China

月亮山就是瀕死的洞穴：圖中這座洞穴位於奇特的椎狀喀斯特地形中，已在侵蝕作用下縮小成一座天然橋。一座宏偉的拱門聳立在植被上方最高 50 公尺處，探險隊員艾蜜麗雅·哈林頓就在這座巨大石拱上往外伸出、甚至水平懸空的地方攀爬。

"Moon hill" is, in principle, the last breath of a cave: Embedded in a bizarre cone karst landscape, the cave has shrunk by erosion into a natural bridge. An impressive arch stretches up to fifty meters high over the thicket of vegetation. Emilia Harrington climbs in the overhanging, even the horizontal part of the massive rock arch.

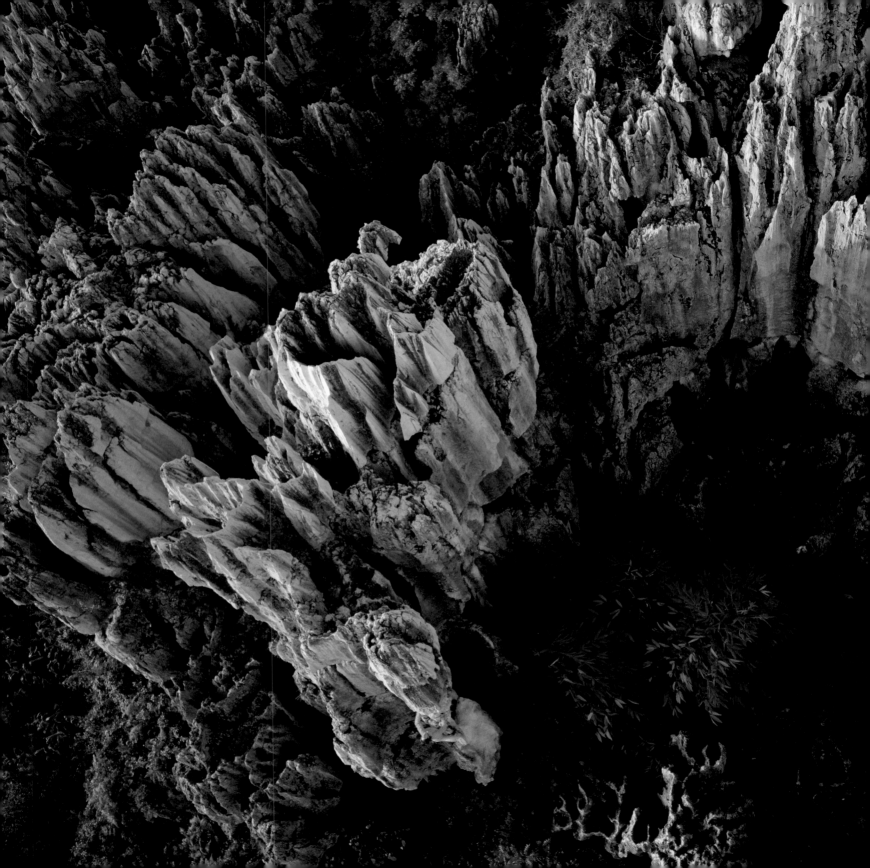

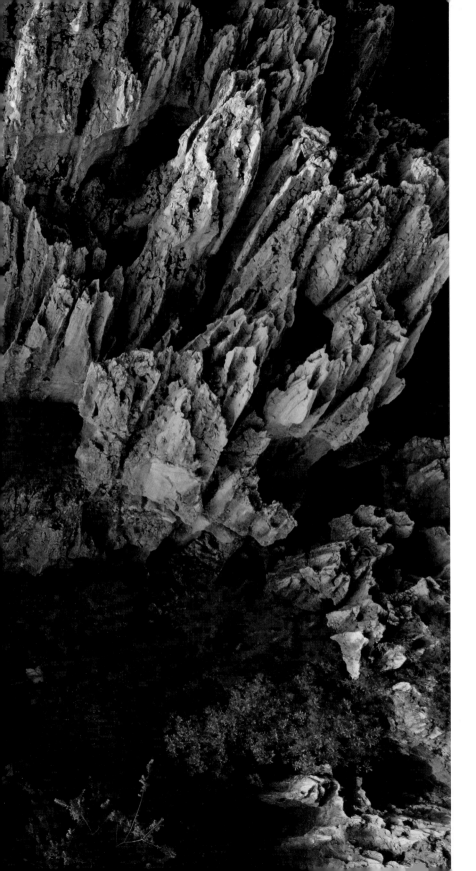

世界奇景
The first wonder of the world

中國，昆明
Kunming, China

昆明石林在明朝時即享有天下第一奇景之譽。從空中俯瞰，鋒利的石柱讓人望而生畏，萬一掉下去後果不堪設想。圖中，探險隊員馬特·席格正在進行困難的初攀。

In the Ming Dynasty, the Stone Forest of Kunming was described as the first wonder of the world. From an air or drone perspective, the razor-sharp ridges form an almost aggressive and threatening composition. You do not want to fall onto these sharp and pointy ridges. Visible in the picture is Matt Segal during a not-so-easy first climb.

經典象鼻龍捲風在索基特（南達科他州，美國）

龍捲風破壞力，是地球上最強、最具毀滅性的。但是相較起來，這經典造型的龍捲風，她的破壞力和造成的災害是相對其他大範圍的龍捲風，算是溫和許多。但是，2003 年 6 月 24 日，確是產生集體風暴創紀錄的一天！在 8 小時內，唯獨在美國南達科他州，造成 68 起龍捲風觸地的經典畫面。

Classical elephant trunk shaped tornado at Woonsocket (South Dakota, USA).

The damage of tornados, the strongest winds on earth, can be devastating. However this classical one was quite moderate and the damage was relatively mild. But it happened on June 24th, 2003. It was a record mass outbrake day in USA, causing only in South Dakota 68 touch downs of tornados within 8 hours. - Unmatched and all together big damages!

龍捲風暴

Storm

「**我**的同伴經常在我背後大喊,要我快走,但我太專注於拍照,往往等到最後一刻,捕捉那剛剛好的一瞬間。」

世界上除了南極洲以外,每一個大陸上都曾有過龍捲風,但絕大多數的龍捲風發生在美國中西部的「龍捲風巷」,每年造成數百萬美元的經濟損失並奪走許多人命。科學家對龍捲風還有許多不了解的地方,比如氣旋如何轉變為龍捲風,龍捲風的結構又是什麼。卡斯坦·彼得有12年的時間都跟隨著名的龍捲風研究員提姆·薩馬拉斯的團隊追逐龍捲風,記錄這種破壞力強大的自然現象,最後薩馬拉斯於2013年5月與他的兒子和一名隊員在強烈龍捲風中喪生。彼得第一張《國家地理》雜誌的封面照片,便是薩馬拉斯站在龍捲風前面,他拍攝的龍捲風照片也贏得了世界新聞攝影大賽。

在國家地理學會的贊助下,薩馬拉斯為了深入研究龍捲風,自行設計發明探測器,並將它放在龍捲風的行進路線上,藉此蒐集龍捲風內部的科學數據。除了龍捲風以外,薩馬拉斯也研究另一個充滿謎團的自然現象:閃電,他發明一秒鐘可以拍下140萬張照片的相機,捕捉閃電的閃光。然而薩馬拉斯不幸在解開謎團之前逝世,留下這台只有他會操作的機器。他的驟逝不僅是科學界的重大損失,也是彼得個人的損失,「追逐暴風再也不會一樣了。」

"**People** often scream behind me, 'we have to move!' But I'm so focused on my camera and I just wait until the last moment. It's always the right split second that you're capturing."

Tornadoes have been observed on every continent except for Antarctica. However, the vast majority of tornadoes occur in the Central U.S., known as the Tornado Alley, resulting in millions of dollars in economic losses and heavy casualties every year. Even today, scientists continue to be puzzled by tornados, how cyclones become tornados, and the structure of tornados. For 12 years, Peter joined the renowned tornado researcher Tim Samaras and his team to hunt for tornadoes, documenting this destructive natural phenomenon until Samaras was killed by a violent tornado, along with Samaras' son and a team member, while conducting research in May 2013. Peter's first National Geographic cover shot was the photo of Samaras in front of a tornado; his coverage on tornadoes also won the World Press Photo Award. With funding from National Geographic to carry out an in-depth investigation of tornados, Samaras designed and built his own probes, deploying them in the paths of tornados to obtain scientific data of their inner workings. In addition to tornadoes, Samaras pursued another mysterious natural phenomenon—lightning. He even devised a camera that could take 1.4 million photographs per second to capture lightning flashes. Unfortunately, Samaras passed away before unveiling the mystery, leaving behind a piece of equipment that only he knew how to use. His passing was not only a great loss for science, but also for Peter personally: "Storm chasing will never be the same."

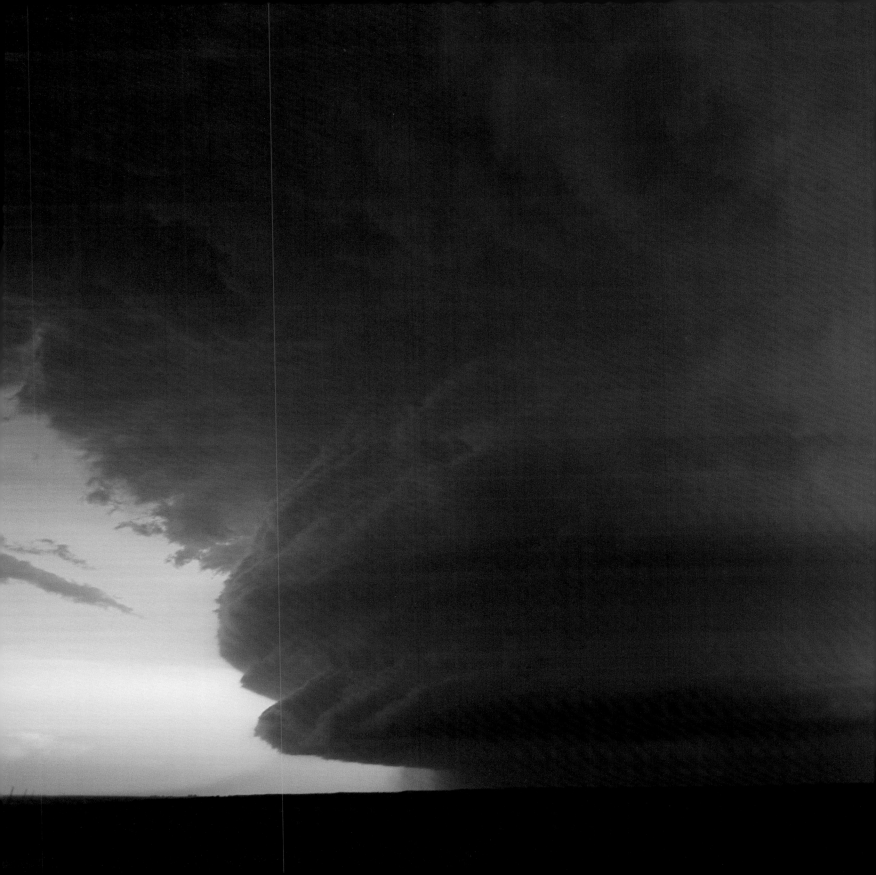

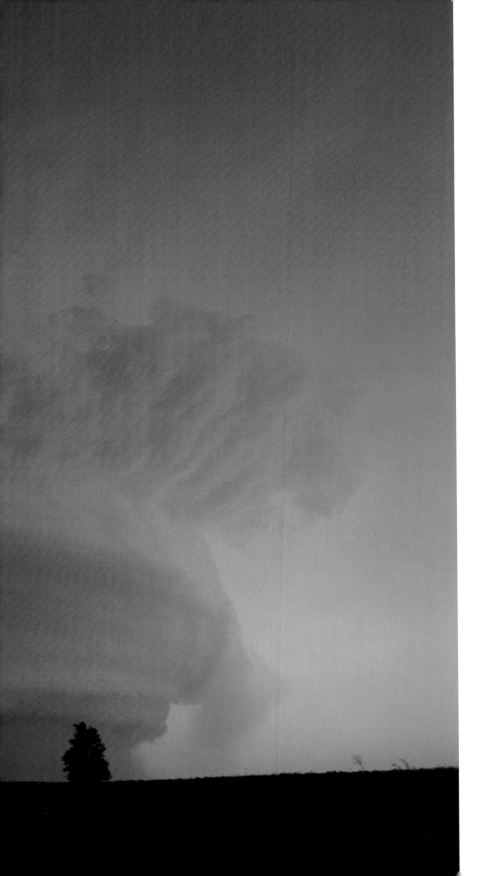

母艦
Mothership

美國，德州契爾卓斯
Childress, Texas, USA

雷暴會藉由旋轉加強自身結構。在惡劣氣候中，巨型的超級雷暴容易形成所謂的「超大胞」，而地球上風力最強大的風暴，也就是龍捲風，就源自超大胞。拍下這張照片時，龍捲風警報大響，彷彿遭受空襲一樣。

Thunderstorms can strengthen themselves by rotating. Especially during bad weather, huge mega thunderstorms, called supercells, can arise. They are also the birthplace of tornadoes, the strongest storms on earth. Now the sirens sound as though during an air raid.

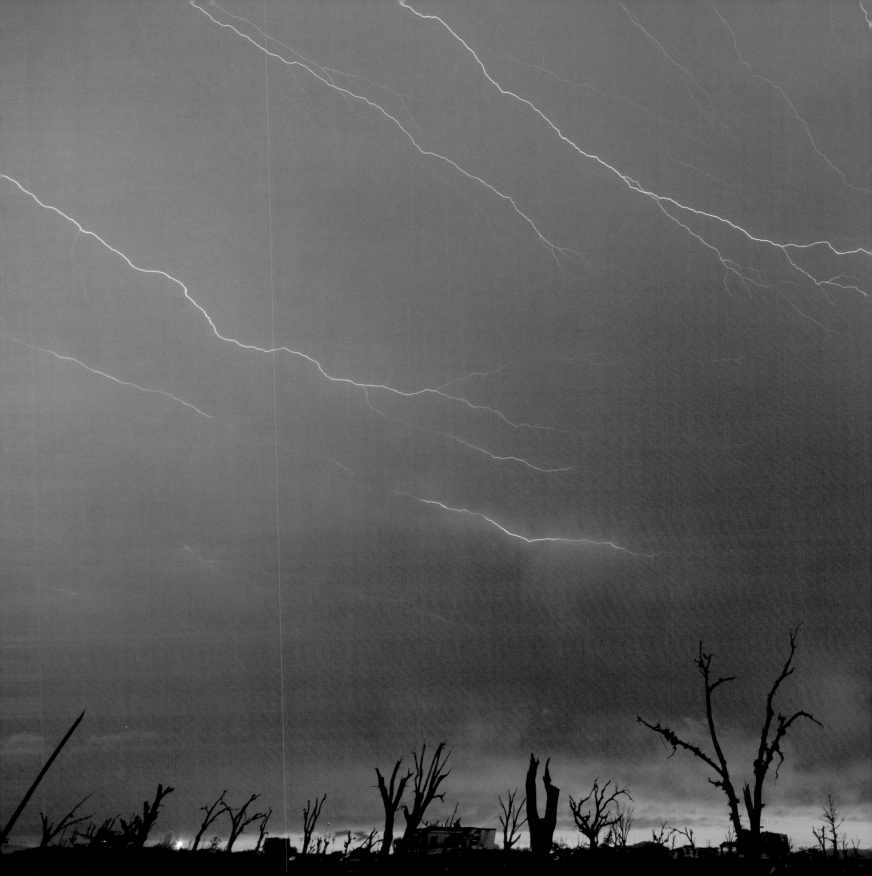

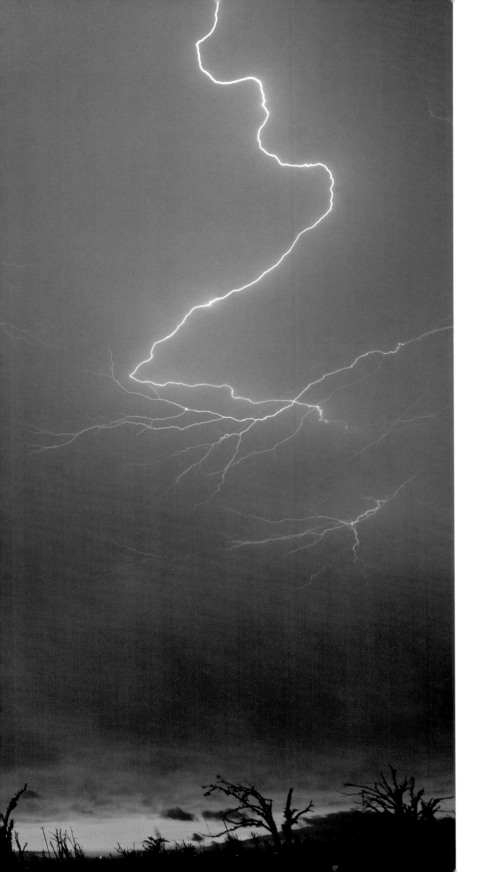

雷電交加
A lot of tension

美國，堪薩斯州格林斯堡
Greensburg, Kansas, USA

2007 年，位於美國堪薩斯州的格林斯堡小鎮被最強等級（EF5）的龍捲風夷為平地。其後的一道風暴鋒面夾帶片狀閃電和沿著砧狀雲下緣行進的閃電，讓小鎮有一種世界末日的氛圍。

In the year 2007, Greensburg, Kansas was wiped out by a category EF5 tornado. One of the following storm fronts with sheet lightning and "anvil crawlers" (lightning that can travel long distances at the bottom of the anvil) gives the place an apocalyptic feeling.

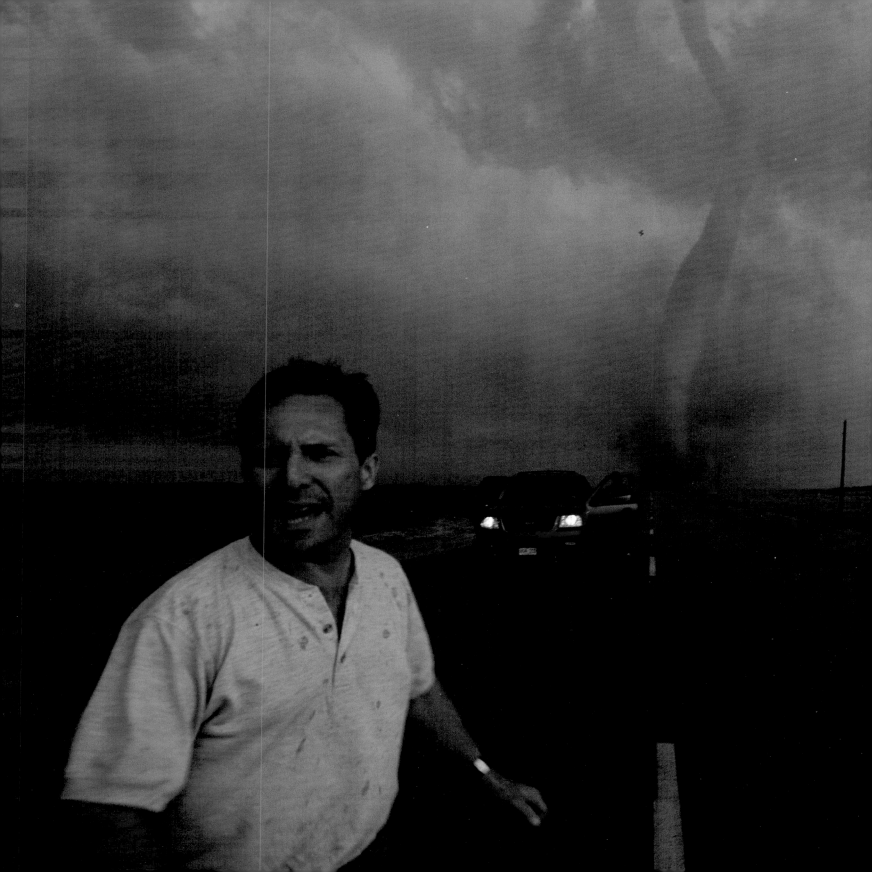

不容閃失
War of nerves

美國，南達科塔州曼徹斯特
Manchester, South Dakota, USA

提姆·薩馬拉斯的臉上寫滿緊張，因為追逐龍捲風不容任何失誤。在照片中這次成功的追風行動後，薩馬拉斯向攝影師卡斯坦·彼得坦承，他再也不想這麼靠近龍捲風。2013年5月31日，提姆和他的團隊遭逢大難：他們在奧克拉荷馬州開車進入自有測量紀錄以來最寬的里諾龍捲風，結果無一倖存。

The tension is etched in Tim Samaras' face. If you are chasing a tornado, you can't make any mistakes. After the successful hunt, he admitted to photographer Carsten Peter that he doesn't want to come that near to a tornado again. On May 31, 2013, he and his team faced a fatal destiny. They drove into the El Reno tornado in Oklahoma, the widest tornado ever measured, and did not survive.

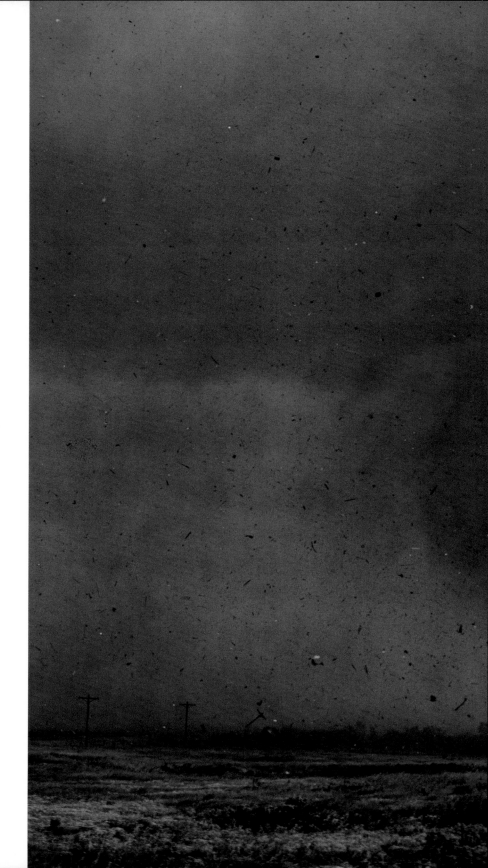

瓦解的村落
A village in a state of dissolution

美國，南達科塔州曼徹斯特
Manchester, South Dakota, USA

2003 年 6 月 24 日是曼徹斯特這座小鎮的末日。一個直徑將近 1 公里的龍捲風將所經之處摧毀殆盡。照片中的一團灰塵實際上是小鎮的碎片：屋頂、牆壁、樹幹、車子—甚至還有在照片左下角可見、被連根拔起的電線桿。

24 June 2003 - The last day in the life of this small village in Manchester. An enormous tornado with a diameter of half a mile destroys everything in its path. What looks like swirling dust is in reality the fragments of a village: House roofs and walls, trees, cars - yes, you can even see on the bottom left that a telegraph pole has been torn off and carried away.

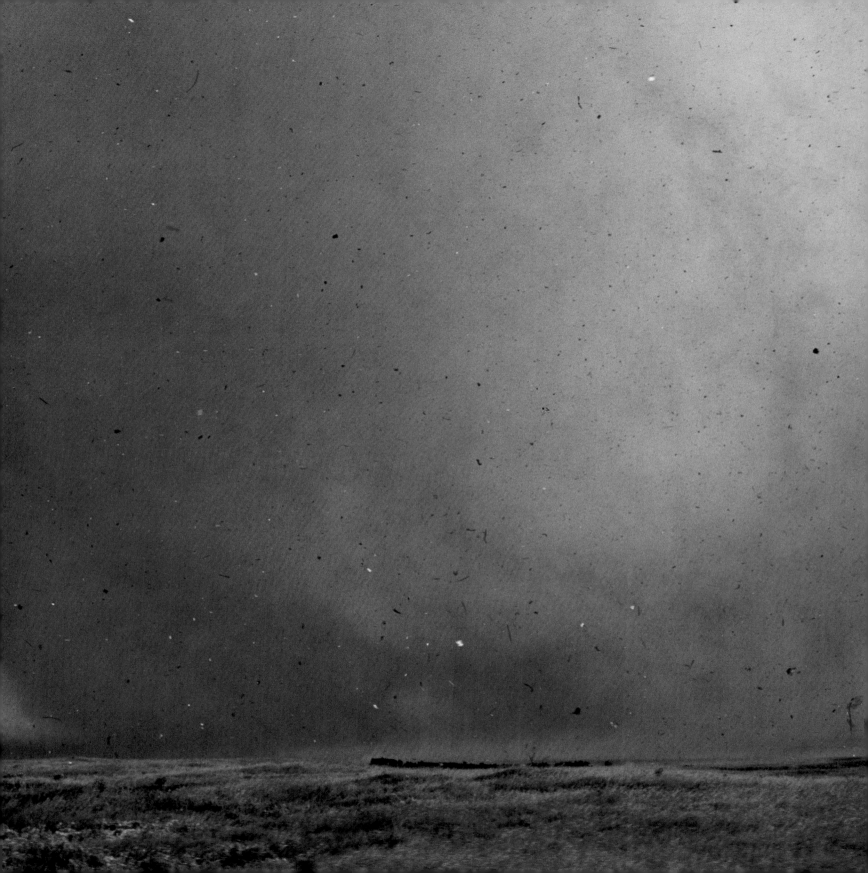

神的審判
"Judgement of god"

美國，科羅拉多州
Colorado, USA

為了讓追逐閃電更有效率，研究團隊專注於暴風雨中心閃電活動量最大的區域。那個畫面彷彿世界末日的最終戰場，閃電以秒為週期發生、震耳欲聾的雷聲緊隨在後，閃電發生前，人的毛髮會因靜電豎起，直到千萬伏特電壓從大氣釋放出來、1 萬安培電流通過為止。正閃電比一般閃電強度更強，可達到 30 萬安培。閃電路徑會加溫至攝氏 3 萬度，是太陽表面溫度的 5 倍。

In order to make the hunt for lightning as efficient as possible, the research team focused on the center of the maximal lightning activity of the storm. One may imagine a scene as though from the Armageddon: Lightning in second long cycles, closely followed by a screaming and air splitting thunder. Hairs stand on end until 10 million volts discharge and the 10,000 ampere sparks glow. Positive lightning is a lot stronger, up to 300,000 ampere. The lightning channel heats up to 30,000°C, five times as high as the temperature on the sun's surface.

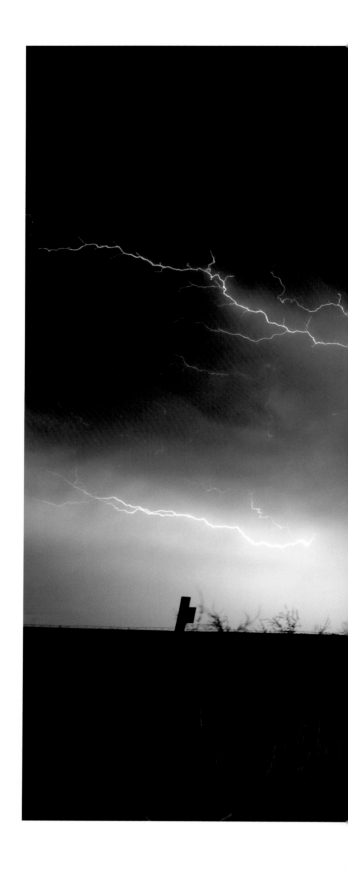

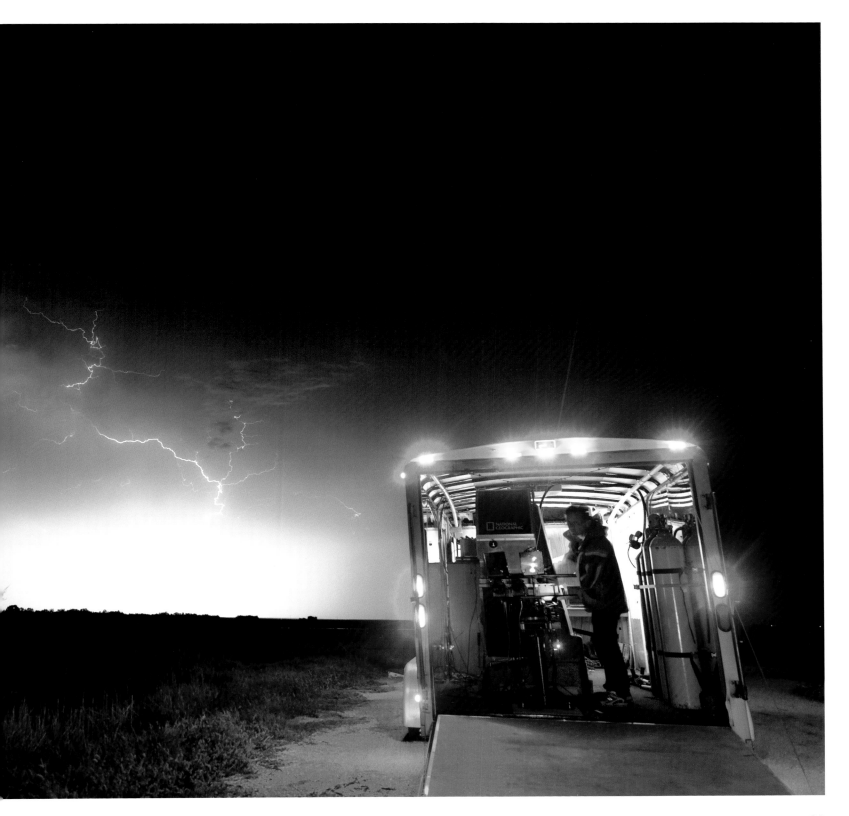

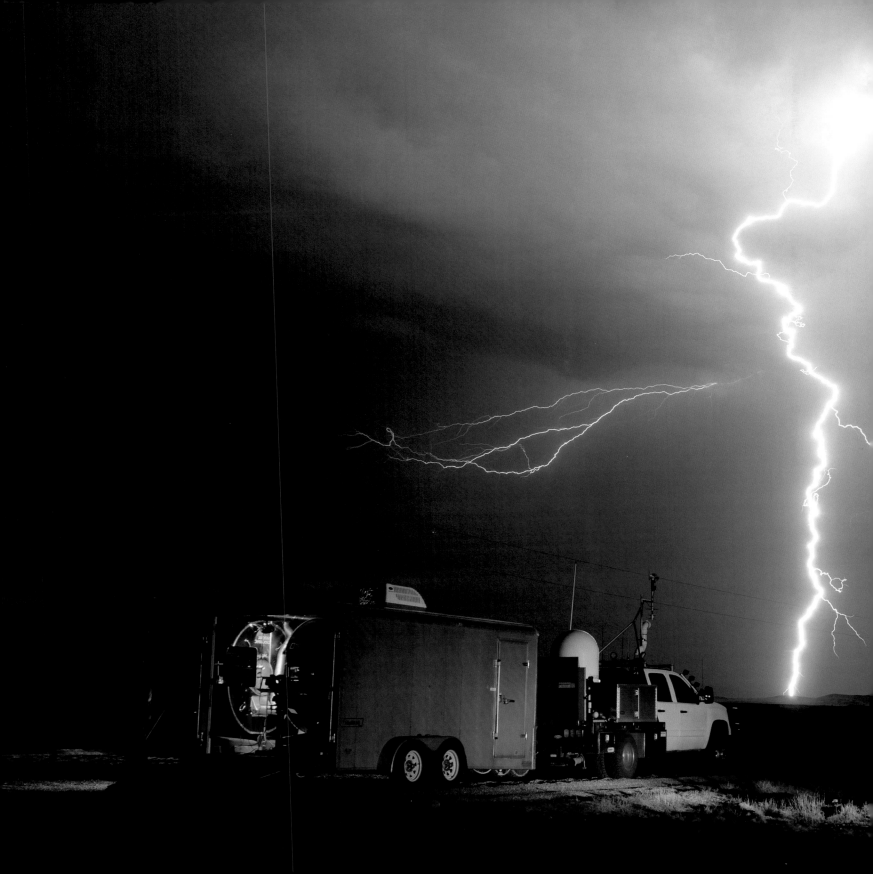

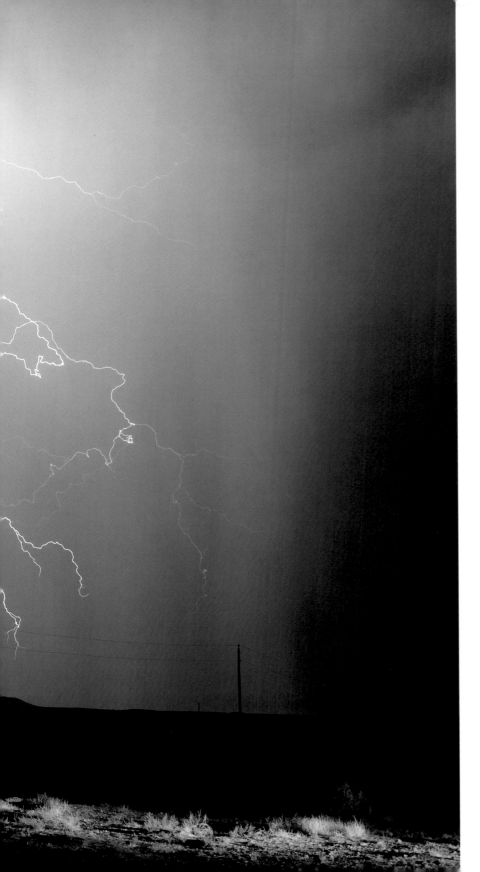

高速追獵閃電
High speed hunt for lightning

美國，新墨西哥州
New Mexico, USA

提姆·薩馬拉斯自創了一臺高速數位相機以更容易觀測閃電。相機將近 800 公斤重，需要靠拖車才能在大草原上移動，每秒最多可拍下 140 萬張照片。操作它最大的挑戰是要離閃電夠近，並在正確的瞬間按下快門。

Tim Samaras created a high speed digital camera so he can better examine lightning. It weighs about 3/4 tons, must be taken into a trailer to drag through the prairies, and has a maximum performance of 1.4 million pictures per second. The most difficult part is to get near enough to the lightning and trigger the camera at the right time.

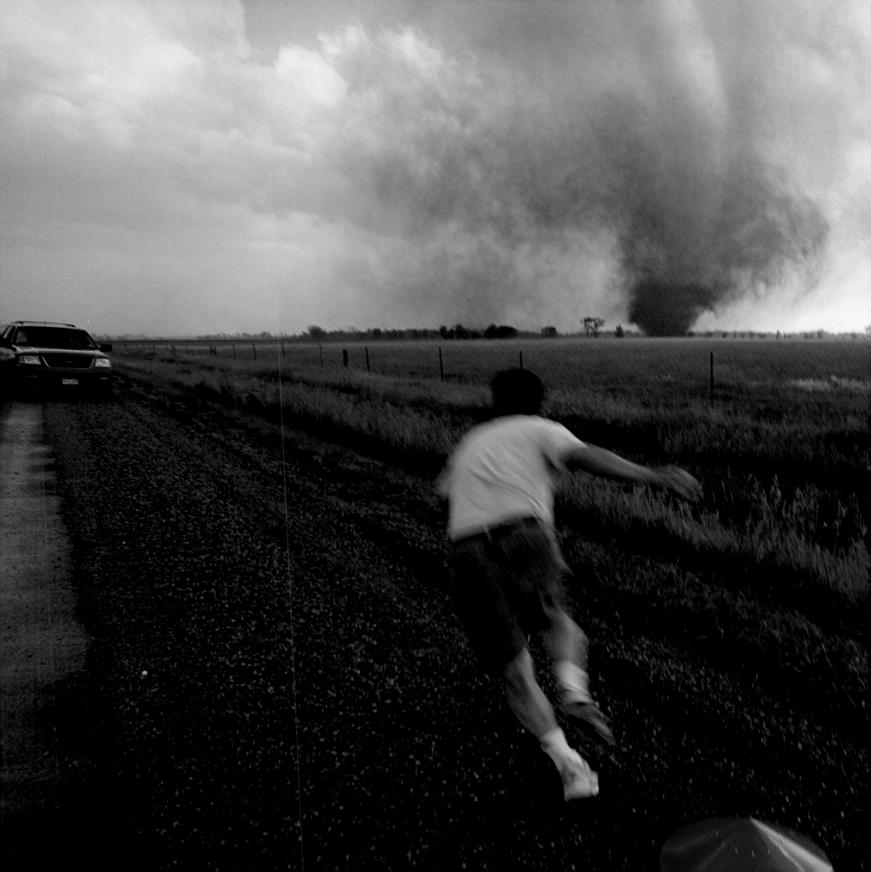

被龍捲風追逐
Hunted by the tornado

美國，南達科塔州溫索克特
Woonsocket, South Dakota, USA

傳奇追風人提姆·薩馬拉斯正在逃離龍捲風。他是第一位將自己研發的探測器放入龍捲風氣流的人，並測得史上最大的氣壓下降數值。這張照片以超廣角鏡頭拍攝，會讓人誤以為龍捲風還很遠，其實龍捲風非常近，而且正快速接近探測器。有時，龍捲風距離薩馬拉斯還不到1分鐘路程。

The legendary storm chaser Tim Samaras is being hunted. He is the first man to deply self-developed probes in the flow of a tornado, and he measured a world record air pressure drop inside it. The extreme wide angle perspective in this photo is misleading: The tornado is very close and is moving quickly towards the sensor. Occasionally it is less than a minute away.

雷射瞄準器
Target laser

美國，科羅拉多州
Colorado, USA

近800公斤重的相機不太容易移動，只能用於瞄準與拍攝。為了精確瞄準閃電活動最頻繁的區域，以及在黑暗中找到方向，提姆·薩馬拉斯製作了一個機動鏡面：定位雷射光束會穿過鏡面，顯示鏡頭對焦在雲的哪個位置。

A 3/4 tons camera is quite immobile except to point and shoot. In order to aim it exactly at the regions with the most lightning activity and to find one's way in the dark, Tim Samaras made a motoric mirror construction: A target laser shot through the mirror arrangement and showed him which part of the cloud the lens is focused on.

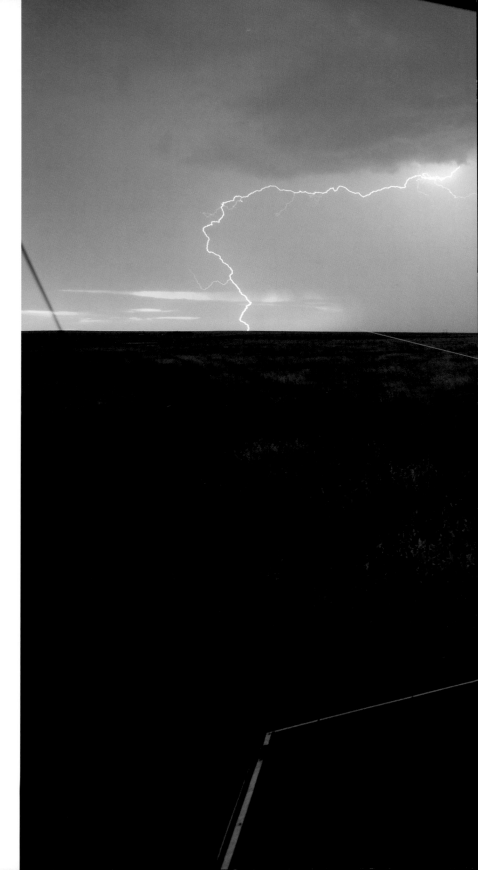

狂熱大地
極限攝影精選
Extreme Planet

作　　者：卡斯坦·彼得

翻　　譯：石艾德、劉憶萱

審　　稿：胡宗香

主　　編：黃正綱

策　　畫：彭龍儀

美術總監：陳其輝

發 行 人：熊曉鴿

總 編 輯：李永適

印務經理：蔡佩欣

美術主任：吳思融

發行經理：張純鐘

發行主任：吳雅馨

行銷企畫：汪其馨、鍾依娟

出 版 者：大石國際文化有限公司

地　　址：臺北市內湖區堤頂大道二段181號3樓

電　　話：(02)8797-1758

傳　　真：(02)8797-1756

印　　刷：群鋒企業有限公司

2016年 (民105) 3月初版

定　　價：新臺幣 320元／港幣107元

大石國際文化有限公司出版

版權所有，翻印必究

ISBN：978-986-92921-3-9 (平裝)

＊本書如有破損、缺頁、裝訂錯誤，請寄回本公司更換

總 代 理：大和書報圖書股份有限公司

地　　址：新北市新莊區五工五路2號

電　　話：(02)8990-2588　傳　真：(02)2299-7900

國家地理學會是世界上最大的非營利科學與教育組織之一。學會成立於1888年，以「增進與普及地理知識」為宗旨，致力於啟發人們對地球的關心。國家地理學會透過雜誌、電視節目、影片、音樂、電台、圖書、DVD、地圖、展覽、活動、學校出版計畫、互動式媒體與商品來呈現世界。國家地理學會的會刊《國家地理》雜誌，以英文及其他40種語言發行，每月有6,000萬讀者閱讀。國家地理頻道在171個國家以38種語言播放，有4.4億個家庭收看。國家地理學會資助超過一萬項科學研究、環境保護與探索計畫，並支持一項掃除「地理文盲」的教育計畫。

國家圖書館出版品預行編目（CIP）資料

狂熱大地 極限攝影精選. -- 初版. --
臺北市：大石國際文化, 民105.03

96面；24x24公分

ISBN 978-986-92921-3-9 (平裝)